Bo Jeffares

LANDSCAPE PAINTING

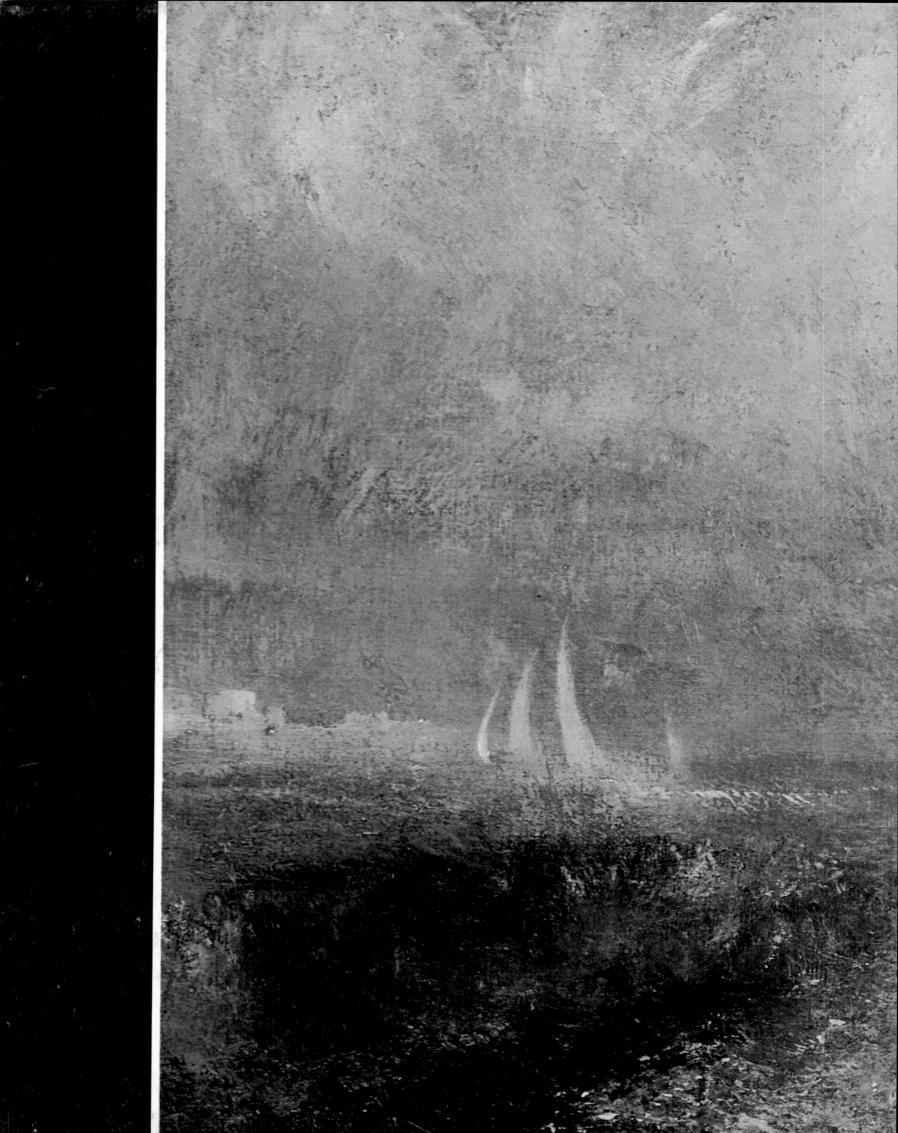

Bo Jeffares

LANDSCAPE PAINTING

The works of Chagall and Dali are © by ADAGP. Paris, 1979, and those by Carra, Dufy, Klee, Magritte, Matisse, Renoir and Vlaminck are © by SPADEM, Paris, 1979.

OVERLEAF Turner: Yacht Approaching the Coast, $102 \times 142 cm$

MAYFLOWER BOOKS, INC., 575 Lexington Avenue, New York City 10022.

© 1979 by Phaidon Press

All rights reserved under International and Pan American Copyright Convention.
Published in the United States by Mayflower Books, Inc., New York City 10022.
Originally published in England by Phaidon Press.

No part of this publication may be reproduced, stored in a retrieval system, or transmitted, in any form or by any means, without prior written permission of the publishers. Inquiries should be addressed to Mayflower Books, Inc.

Library of Congress Cataloging in Publication Data

JEFFARES, BO.
Landscape painting.

 $\begin{array}{cccc} 1. \ Landscape \ Painting - History. & I. & Title. \\ II. & Series. \\ \text{ND}1343.J43 & 758'.1 & 78-25573 \\ \text{ISBN} \ 0-8317-5413-3 \\ \text{ISBN} \ 0-8317-5414-1 \ pbk. \end{array}$

Filmset in England by Southern positives and negatives (SPAN). Lingfield, Surrey
Manufactured in Spain by HERACLIO FOURNIER SA, Vitoria.
First American edition

Rembrandt (1606-69): The Stone Bridge, 29·5× 42·5cm

Rembrandt may be best known for his style of painting portraits in which a sitter's face looms out of a dusky background. One is not aware of pure physiognomy, so much as an indefinable sense of personality. This is evoked rather than stated. The same power of suggestion is at work in this landscape and leaves one with a similar sense of mood; something hard to define, but too potent to ignore. Rembrandt deliberately transcends matter, whether stone or flesh. If he had wanted, for example, to be more factual about a construction like this, he would have chosen a different kind of lighting; the dark and light in this work - emanating from thin air - make a blurred synthesis of the curved and reflected form of the bridge. Although he was able to draw with remarkable realism, Rembrandt preferred, here, to manipulate what he saw, to produce an atmospheric effect.

Take a leap in time, imagine the same bridge in Cézanne's hands. The murky cohesive blurs of Rembrandt's sombre brush work will be replaced, in your mind's eye, by something harder, brighter and more abrupt. Each fissure in bank or bridge will be cut and pinned, as by a surgeon's knife. Look again at the Rembrandt – and appreciate its softer mystery.

LANDSCAPE PAINTING points to the flexibility of the human mind, for artists are always altering their ideas about their environment to suit the philosophical and psychological needs of the day. Their temperaments, and their skills, provide a unique record, partly poetic and partly scientific, of the way in which we see the world around us. Defying the flat surface of the canvas, artists cultivate and clarify the eternal myth of the earthly paradise.

European beginnings: the influence of the church

Much of the character of European painting comes from the nationality of the artist concerned, and the particular places which inspired him. But early on, when landscape painting was in its infancy, there was uniformity in style, resulting from uniformity of beliefs — hence such a term as 'International Gothic'. This term arose from the fact that the

Catholic church, linking Europe as a religious unit, dominated people's thought to a large extent, and influenced the way in which they saw and responded to the life around them.

Nature: a suspect force

The church taught people to consider nature symbolically, to treat natural phenomena in terms of what they represented, rather than what they were. Painters saw things in isolation (often concentrating on quite small items) which they depicted by a system of spiritual hieroglyphics. Thus a lily was not so much a patch of colour, or even a botanical species, as a symbol of the Virgin's heavenly purity, its white colour representing purity, and the double triangles of its petals evoking the divine trinity. As man was encouraged to strive for spiritual perfection, putting his material existence

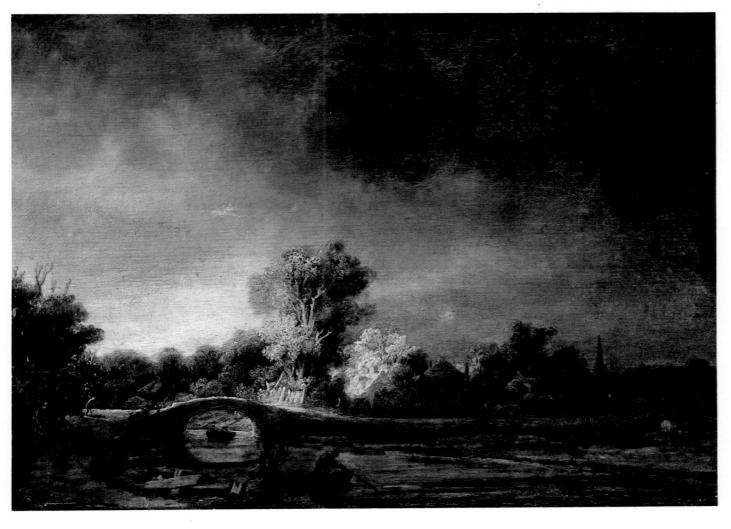

behind him, the actual appearance of his physical life was often seen as an unnecessary source of disturbance, just as Muslim teaching prohibited representational art for similar reasons.

Symbolic narration

Religious dogma accounted, in part, for many of the seemingly naïve paintings crowded with apparently disconnected objects such as disproportionately sized people, angels, bushes and dwellings. These images may appear to the modern eve to have been jumbled together without rhyme or reason, but the logic behind them was often a narrative rather than an aesthetic one. Many early medieval artists were anxious to depict the story correctly (especially in the days of the Inquisition), and, for example, in a picture of a miracle, they would include at each stage of the event the right props whose size, moreover, accorded to their importance in the narrative. Thus a wood by a cliff might be reduced to a series of blobs beside a zig-zagging line, and the whole scene dwarfed by enormous monks or nuns - visual incongruities which might well have been accepted by contemporary viewers whose primary interest lay in recognizing the basic elements of an orthodox tale.

Mountains: beyond the grasp of the medieval mind

The emblem for a mountain was particularly archaic, showing a complete lack of natural observation. Adapted with little modification from early Hellenistic designs (which had inspired Byzantine sketches of the outcrops of Sinai) medieval mountains were absurd. Bent into astonishing contortions, they appeared like stranded pieces of driftwood in compositions where they were connected neither with each other, nor with the landscape around them. As a device, however, they proved popular for a long time, cropping up in otherwise homogenous landscapes like potent folk myths in otherwise civilized literature. Later landscape paintings by Leonardo and Bruegel prove this continuing fascination.

Lorenzetti: Scenes from the Life of the Blessed Humility

Sienese painters respond to natural beauty

Giotto, the Florentine master of expressive figure groups, supplied his figures with plain rocky backgrounds. The first real landscapes, however, came from Siena. Ambrogio Lorenzetti's frescoes, Good and Bad Government, contain factual landscape details which are almost a hundred years before their time, while Simone Martini's paintings are renowned for their graceful interpretation of nature. There is grace, too, in the decorative wall paintings found in the Palace of the Popes at Avignon. Dated 1343, these wall decorations probably represent a well-established fashion: they are richly-patterned, attractively-spaced pictures of people enjoying the outdoor life. This demand for rustic imagery in a great palace is telling. As man's urbanizing programme has increased and his control of his wild surroundings become more extreme, the kind of innocent interest in rustic life, captured so early in Avignon, has become an escapist obsession. It was significant that Simone Martini's friend, the poet Petrarch, was the first modern man who records climbing a mountain to satisfy his sense of curiosity. enjoying the unfolding vista for its own sake.

Fear creates a restricted paradise

Painting of delicate bowers where the Virgin and Child relaxed were popular throughout the fifteenth century. Their development was an obvious antidote to the harsher realities of medieval life, for Europe, at this time, was still covered in wild forests, replete with wild boars and bandits. While man was still surrounded by a savage environment he naturally sought solace in signs of civilization suggesting safety. Thus he not only worked to cultivate the land, in practical terms, but also developed the intellectual idea of the enclosed paradise garden or *hortus conclusus*. This was an edited image of a town plot or country orchard where man's control over nature was far more obvious than nature herself. Plants laid out in ordered patterns or flourishing in formal beds would often surround a fountain. The fountain itself was a tradi-

Unknown Florentine painter: The Thebaid (detail)

Bad painters take heart. Here is a painting chock-a-block with faults that have survived for 400 years. Not only are these sentry box buildings, naively constructed, set at contradictory angles and all far larger than the chapel in the foreground, but the hillside itself, inclining to the right at an angle of forty-five degrees, is scarcely convincing. Nevertheless, this picture has its charms. The care which went into the composition of the gravel and into synthesizing folds in garments and cracks in rocks; the ingenuity which suspended a bell from a rope and showed how water forced the mill wheel to turn – they all with the invention underlying this tightly packed picture warrant consideration.

This unknown artist who provided such a wealth of picaresque detail arranged his trees, buildings, rocks and figures with enormous variety, shaking up his basic materials to make an integrated whole. There is no surprise in discovering a monk up a tree or under a crevice, for this busy self-absorbed community inhabits its rocky landscape with the deliberation of ants on an anthill.

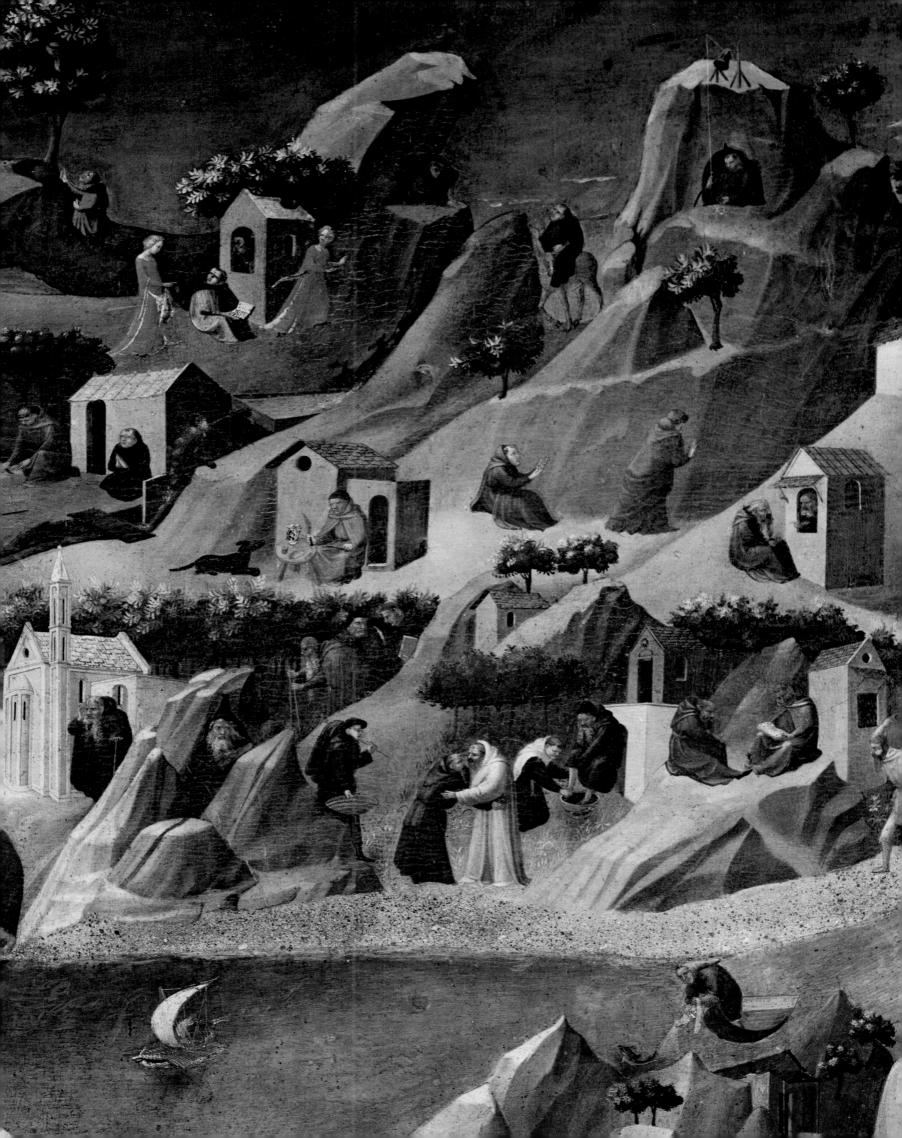

Landscape Painting: Master of Flémalle

tional symbol of man's control of the elements, representing a safe half-way house between the disasters caused by flood and drought. The neat pailings round so many of these painted enclosures are decorative reminders of an age when stockades and battlements were essential for survival.

Craftsmanship

The medieval mind did not attempt, at first, to enlarge its idealized garden, but to enrich it. Enormous care and energy were devoted to making individual details as finished as possible. The closely-woven rose hedges and flower-speckled lawns dating from this period have much in common with

Master of Flémalle: Virgin and Child and Saints in a Garden, 119.7×148.6 cm

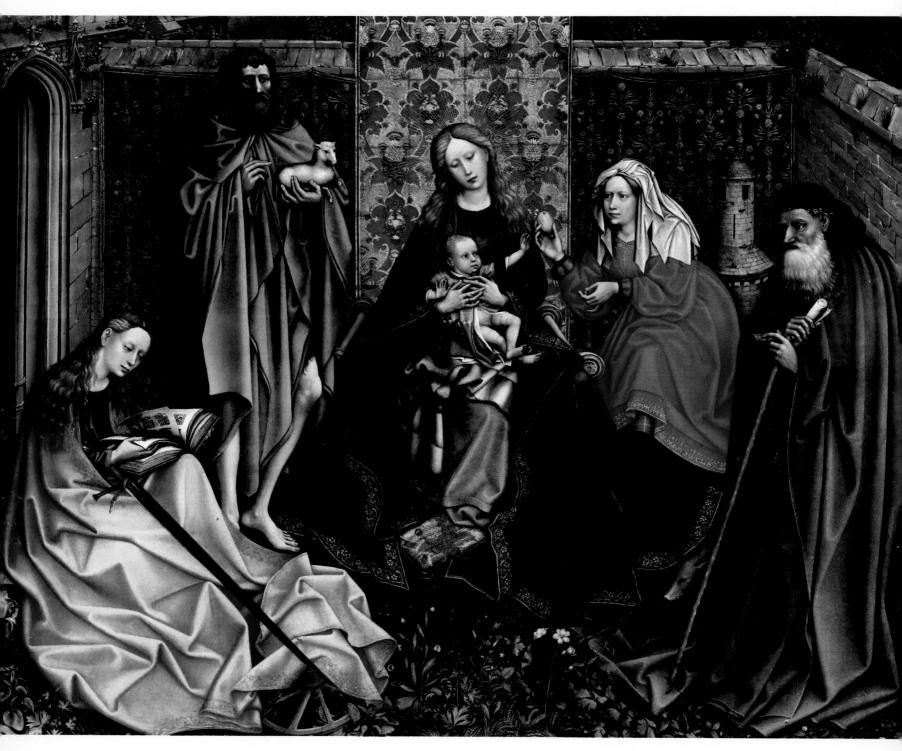

Giovanni di Paolo: Paradise, 47 × 41 cm

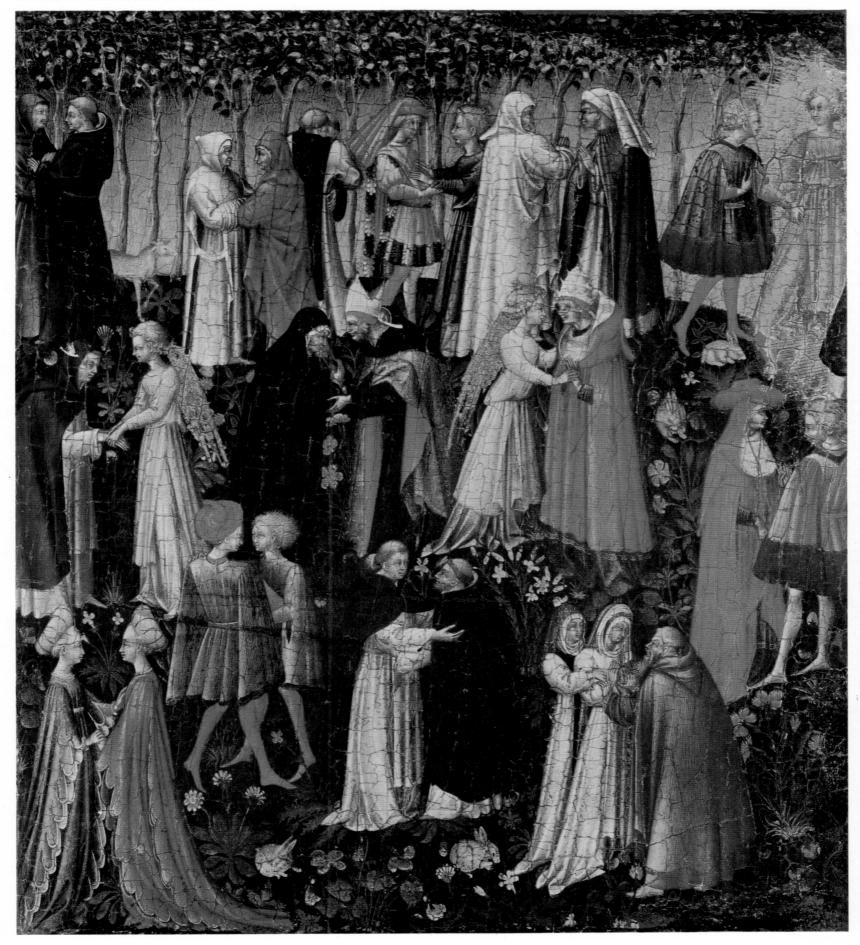

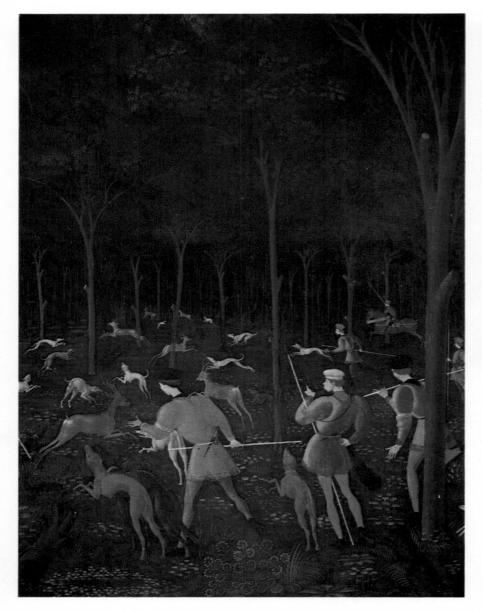

tapestry, or with jewellery work. Nature in perfectly chiselled fragments is fitted into fine mosaic patterns; and yet these exquisite images contain the germ of landscape painting. European man had begun to respond to the world around him.

Books of Hours

The kind of life one leads determines one's connection with the land, and in the Middle Ages that connection was a very basic one: nature was seen, by the sharp eye of the hunter, as a source of food and also as the natural background to daily life. Nobles hawked for sport, and peasants tilled the fields. Such activities were recorded with objective clarity in precious seasonal calendars, originating in the courts of France and Burgundy around 1400. One of the manuscripts, known as the *Très Riches Heures* of the Duke of Berry, places the occupations of each month within their section of the sacred calendar, in miniatures of crystalline perfection. Painted by Pol de Limbourg and other artists from the Low Countries, these symbolic pictures contained a rich ballast of

Uccello (1396/7-1475): The Hunt (detail)

Look at this painting, and then close your eyes. The colours which remain in your mind are scarlet and white. The old cliché of a landscape being an applegreen hummock under a cerulean sky is immediately dismissed. Examining the painting you will find areas of pink, lilac-grey and yellow as well as scarlet. After a few seconds you will notice fawn, rust, black and olive. The last colour, a uniform ground, is embossed with leafy patterns. And as your eye searches among the high branches in the wood you may find other leafy variations on a patch of midnight blue. But these elegant details (submerged in a general impression) pale beside the primary effect of this painting, one of strong visual contrasts. As a quick analytical sketch will reveal, Uccello's rigid ink forest forms a perfect foil to the variegated band of brilliantly-coloured silhouettes.

The central part of a long panel, painted to decorate a chest, this image shows huntsmen converging behind leaping, fleeing animals. They are enacting a primitive ritual, as vital in their own day as mass-produced food is in ours, and thus illustrate the fact that a work of art can serve as an historical record as well as being an accomplished design.

direct observation, the heritage of the practical, Northern States. This style spread to Italy. Southern artists, such as Gentile da Fabriano, Pisanello, Uccello and Gozzoli, drew inspiration from these Northern manuscripts, copying fanciful hunting scenes set deep in dark woods and forests.

Light breaks in

Light was often suggested in the Middle Ages by disconnected, symbolic means. In a painting of 1423 by Gentile da Fabriano entitled the *Adoration of The Magi* the sun is literally represented by a golden disc, its light by gold underpainting. This alchemical interpretation could be compared with the kind of symbolism found in stylized ancient art, such as that of ancient Egypt. Thus the beneficial effects of the sun were described on the back of Tutankhamen's gold throne by long beaten rays ending in hands that bless. In the Adoration of The Lamb of 1425. Van Evck painted thin gold rays radiating down to earth in the same fashion, while at the same time his powers of direct observation led him to a much more sophisticated formula. Ignoring hard outlines and crude blocks of colour, he created a tonal landscape lacking the rigidity of earlier works. Similarly relaxing all the boundaries of the hortus conclusus, he painted individual thickets in groups instead of encircling his entire landscape with a barbed bower. His fountain of life stands in an opening landscape where the luminous quality of light lets the distance evaporate naturally into space.

The elements: basic factors in landscape painting

Facts are facts and fall within the realm of concrete reality, but light is ethereal and therefore poetic. The mystic, melting effect which van Eyck achieved in the *Adoration of The Lamb* illustrates the absorbent unity which light can create.

A landscape, as the word suggests, deals with an artist's reactions to the land, but the land never exists on its own. It is the subtle, and sometimes not so subtle, interplay between the elements which gives landscape painting its dramatic possibilities. Obvious earthy elements, sand, soil, minerals and mountains, cannot be seen in isolation. Their solidity is always being moulded by their more illusive brethren, air, fire and water. Water, for example, can mark the land in many ways, and not only when contained in seas and rivers, building up banks, wearing down rocks, but also in the form of winding streams, reflective lakes or blanketing snow. The alterations in vegetation which these changes affect, as marshes are created or leaves driven from the trees, are all an integral part of our landscape. Masked with a sheet of rain, or covered in an ethereal mist, the earth's crust takes on new pictoral possibilities, while fantastic cloud shapes can not only shadow the earth below, but create rival landscapes in the air. Clouds, in turn, are lit and tinted by the sun, the all powerful element of life. Its fire, which has the power to scorch and burn, merges with our protective air to produce an atmospheric envelope of great beauty. It is perhaps our daylight, more than anything else, which makes our world unique. Painters of landscape are painters of light.

European painters have been blessed, in particular, by everchanging weather conditions, unlike the pink glare and

purple sunsets of Mars, or the cruder climatic conditions found at the Equator or the Poles. Artificial light aside, European painters have devoted endless effort to evoking subtle nuances of luminosity. Daylight, hot and cold, delicate dawn light, sleepy evening light, sunsets and sunrises, light on hazy autumn days or fresh spring ones, and all the endless visual variations found in Europe are mainstays of her landscape tradition.

Light as a key to atmosphere

Any landscape alters as the light plays on it. Everyone is well aware of this, for the places where we live and work seem gloomy on dark days, more cheerful on sunny ones. Atmosphere, in a physical sense, affects mood, in a psychological sense. And while everyone is aware that atmospheric conditions have their mental counterparts — phrases such as 'black as thunder' suggest a glowering temperament — painters, in particular, have made it their business to develop this awareness to a professional pitch. Just as composers select a specific key to stimulate a particular kind of emotional response, so landscapists use different kinds of light to set the emotional tone of a painting.

Northern precision

Light could be used glowingly, as by van Eyck, to give a physical scene a spiritual transparency. The obverse side of this Northern coin was exactitude, sharp delineation. Robert Campin (also known as the Master of Flémalle) developed the hard crisp style of Pol de Limburg and his brother into knife-

LEFT Fra Angelico: *The Annunciation* (detail) Fra Angelico: *The Annunciation*. 194 × 194cm

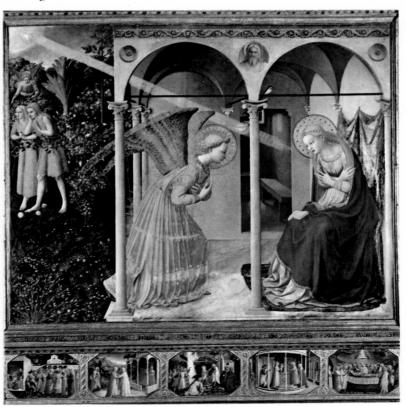

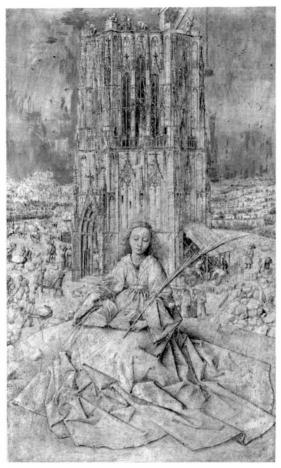

Jan van Eyck: St. Barbara, 31 × 18cm

edge precision. Campin's far distances have a magnetic brilliance which seems to exceed the bounds of normal vision. His linear clarity, and that of painters like him, works particularly well in the depiction of frozen winter landscapes. The stark lines of trees and their tapering branches are naturally bent to suit the awkward grace of the late Gothic.

Topography

The accuracy with which landscape details, such as Campin's, were recorded indicates on-the-spot observation. But where Hubert van Eyck's full tonal and colouristic cohesion suggests watercolour sketches, many of the stiff, detailed masterpieces created in the Low Countries suggest a wealth of preliminary drawings – they could hardly have been created from memory. Hubert van Eyck's brother, Jan. who outlived him, was more likely to have started with silver point drawings. The precision with which he captured Old St. Paul's (at the back of an image of the Virgin and Child with Saints) typified the kind of objective scrutiny which became closely associated with Northern artists. The first topographical study was by Konrad Witz, who included a meticulous account of his own native lake, that of Geneva, in the background of the Miraculous Draught of Fishes of 1444. Dürer's topographical views, begun in 1494, show how his intense, uncompromising gaze could dissect the peculiar character of a place with the impersonality of a laser beam; his drawing of Innsbruck is probably the first real portrait of a town. Even small drawings like this represent a change in the development of landscape painting, showing how the landscape of symbols was gently eroded by other forms.

Looking out: curiosity increases

As landscape painting grew in importance, the figure (which had so often dominated medieval canvases) grew less obtrusive. And tiny landscape backgrounds formerly glimpsed through a far window grew literally in size and significance. Indeed, the device of the painted window can be taken as a symbol of a new mental attitude: the desire to look out on the world and to investigate it for its own sake.

Large, icon-like images of the Virgin with a decorative trimming of rose hedge, or a microscopic view of the artist's own garden, gave way to fuller paintings in which a land-scape setting became every bit as important as the subject it contained. Landscape was now a complementary factor. The physical solidity or spiritual dignity of a figure, or group of figures, was frequently enhanced by sharp foreground details (such as plants and stones) or rustic anecdotes (such as agricultural episodes) or by ethereal horizons (such as transparent mountains vanishing into the clear sky).

Giovanni Bellini was the undoubted master of the kind of richly balanced painting in which man, his works and his environment all existed in perfect harmony. Everything fits into his pictorial plan, and yet each individual detail is painted with affectionate precision. In the *Madonna of the Meadow*, for example, the central triangle composing the Madonna and Child is painted with elaborate care; the silken folds of her dress are neither rushed nor primitive, but then

Dürer: Castle Courtyard, Innsbruck(?), 33.5×26.7 cm

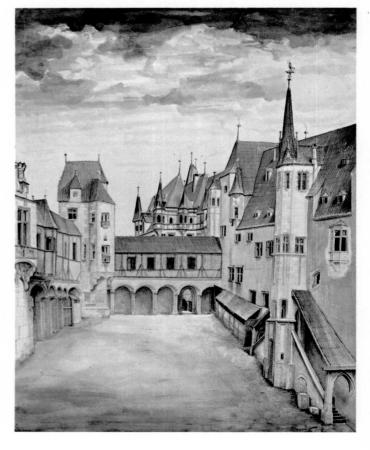

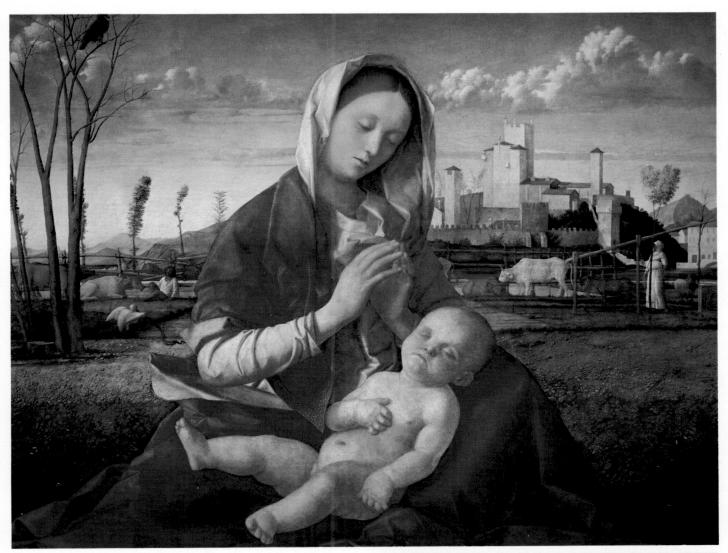

Giovanni Bellini: The Madonna of the Meadow, 61×83.8 cm RIGHT Giovanni Bellini: The Madonna of the Meadow (detail)

neither are the natural images filling the two lateral, landscape vistas to either side of her. The practical precision of the Middle Ages and the all pervading humanism of the Renaissance have come together here to produce a work of quiet wonder.

Bellini has caught the exact beauty of an Italian hill town, bare tree, black bird, furrowed field: each object is unique, yet held together in the same mellow light. Bellini's mastery of light, stemming from van Eyck, is an essential part of his genius, for he is able to make a whole scene glow with calm, absorbed warmth. The deep gentian cloth covering the Madonna finds its perfect foil in the dried earthy background behind her: logic and inuition work hand in hand, the land-scape reflecting a wise love of life.

In the *Madonna of The Meadow*, Bellini was developing a traditional formula — breaking the bounds of the old *hortus conclusus* to let in more space and more life — but he still retained a discreet measure of control over his earthly paradise. There is nothing wild about this landscape: it is significant that a field is being cultivated, while the secure walled city in the distance suggests a safe retreat. Bellini's Madonna is very much a part of the civilized world.

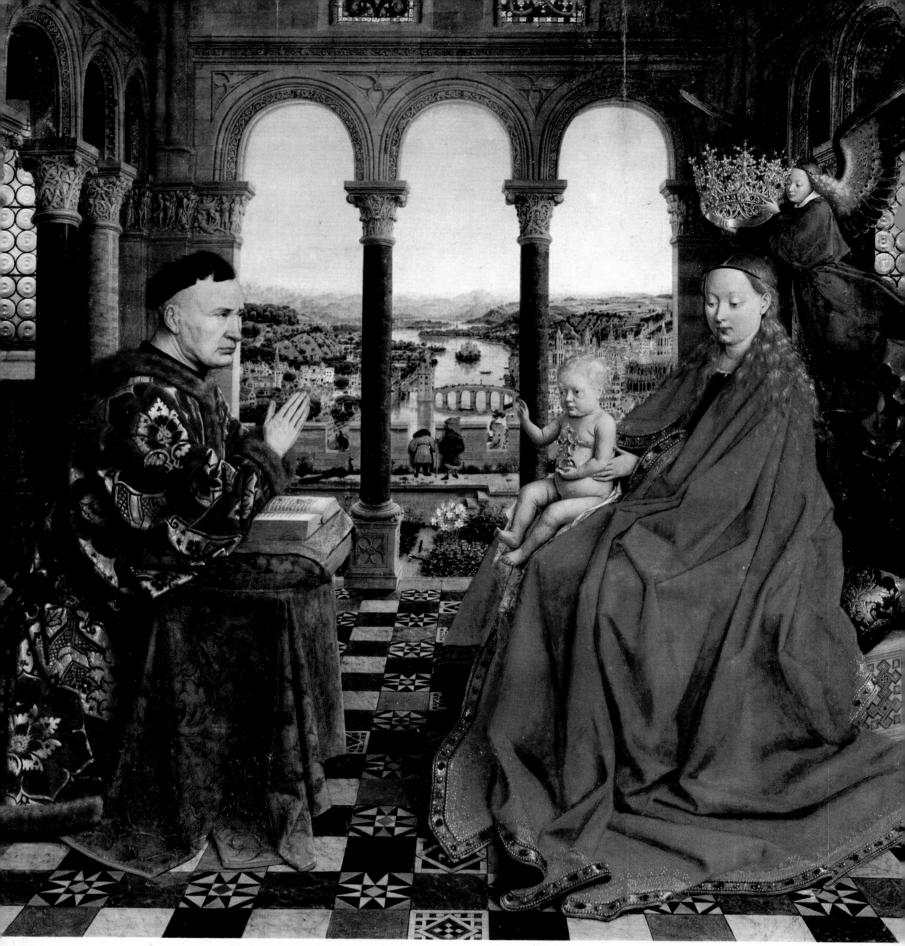

Jan van Eyck: The Madonna of the Chancellor Rolin, $66 \times 62 cm$

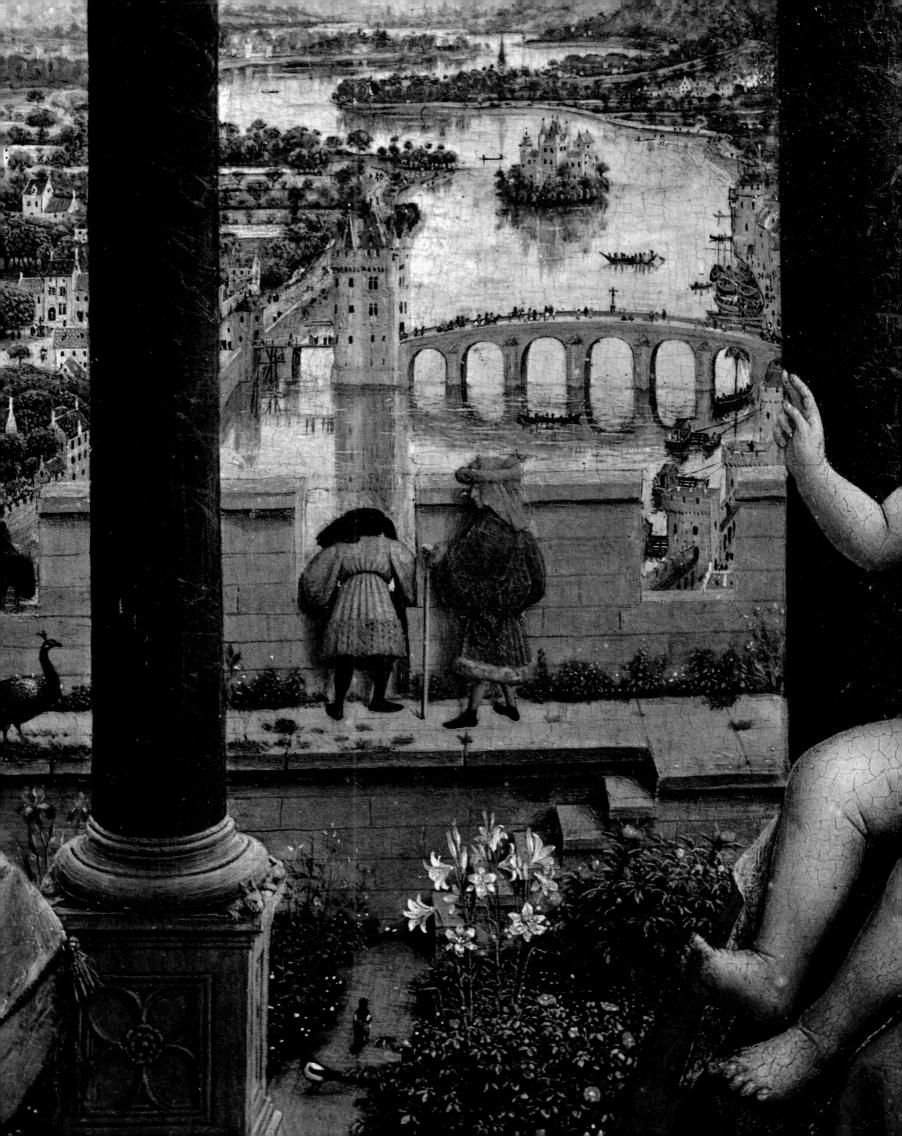

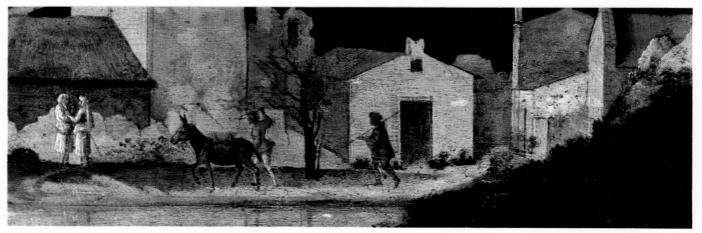

Giovanni Bellini: Allegory of Souls (detail)

More intriguing is the highly individual composition known as the *Allegory of Souls*. If you were to cut this painting through the centre, following the line of the horizontal rail which Bellini has provided, you would find two quite different landscapes. This schizophrenic effect might well be read as an allegory of landscape painting. The lower section is entirely formal: the eye rests on a paved outdoor terrace, painted with the abstract precision of a black and white chess board, where nature is represented by a single, potted tree — a tidy tree of life whose neatly shaped foliage, suggesting topiary, is as regular as its container. But the viewer looking up and into the distance encounters other quite different trees, for far across a stretch of calm water Bellini has developed a natural landscape of surpassing subtlety.

The hermetic tradition

The figures in Bellini's *Allegory of Souls* include a Virgin and two cupids: Christian and pagan symbols placed side by side in a deliberate effort, typical of the Renaissance, to praise man, rather than any one system. Many Renaissance artists evoked classical mythology, with its cult of the hero, to foster a hermetic belief in shared divinity. Whereas, in the Middle Ages, artists had often illustrated a belief in God's

Giovanni Bellini: Allegory of Souls, 73×119cm

superiority contrasted with man's inferiority — painting donors several sizes smaller than saints — in the Renaissance man was given a larger part in the evolutionary chain.

Secular landscape

Landscape details which had first crept into the backgrounds of religious works became increasingly associated with secular ones. Just as the theme of the Virgin in her rose bower had inspired poetic praise of courtly ladies, so Bellini's cupids, or Botticelli's Flora proclaim a shift in interest from divine to earthly love — a change Titian later encapsulated in *Sacred and Profane Love*, an implicit comparison of two women in a landscape setting. This painting reflects the confidence of the Renaissance: the two women are relaxed, their bodies providing the central pivot of the composition and implicitly governing its scale.

The Renaissance: aggressive open-mindedness

Looking is not a simple matter. Individuals see differently—registering their own range of colours and scale of distances, and editing their vision to correspond to their mental state. After an accident, when a host of by-standers are asked to describe what they actually saw, their accounts—all truthful in their own way—vary enormously. Similarly, a landscape interpreted by painters from successive historical periods would inspire a gamut of different paintings. Each age sees what its beliefs enable it to see.

In the Renaissance, people became dissatisfied with their accustomed symbolic way of looking at nature in isolated units. Wanting to evolve, they discovered new methods of questioning and looking more effectively, more scientifically. Mountains, for example, stopped being isolated lumps dropped into a vista like so much gravel off a shovel, and were considered in greater depth. Their strata and geological formation came under close scrutiny. The air was full of intellectual curiosity and personal pride; an explosive mixture. Renaissance man wanted to know how his world worked, and felt up to the challenge. This aggressive openmindedness bore fruit. Endless exploratory drawings, such as Leonardo's studies of rocks or of the magnetic way in which water twirls and curls and girates into movement, provide proof of the way in which artists tried to see more

realistically and more comprehensively. They were not seeking new material so much as new information about that material. This gained, they portrayed their world with startling intensity, using perspective, a purely mathematical formula, as a logical way of linking objects in space.

Space defined in the South

Space, which had been intuitively appreciated in the North by Pol de Limbourg and Hubert van Eyck, whose love of light led them to paint gentle, natural regressions, was tackled somewhat differently in the South. It was organized according to a rational plan. Italian paintings often seem, once one has located their all-important vanishing point, to be pulled together on iron wires. Verticals stand taut while connecting diagonals cut into the distance with perfect precision. It was no coincidence that the rational Florentines, who defined art in terms of certainties, and also considered that the 'real' was something which could be exactly plotted in space, owed their formula for controlling space to an architect — Brunelleschi.

Landscapes defined by perspective

Italian perspective, like any other scheme, had its short-comings. It is worth remembering that it is only one of several systems of defining space. Classical artists, for example, had a method of painting people and objects in a kind of perspective, the only catch being that they had no method

of linking them. The Chinese, on the other hand, devised a system which was the reverse of the Italian method: a square stage drawn by the ancient Chinese would have appeared as a rectangle, with the widest plane at the back.

Limitations

The kind of rational perspective advocated by Alberti and his ilk could not work in every situation, especially as there was a basic confusion between science of the geometrical sort and science of the naturalistic kind. Brunelleschi himself was forced to put a plain sheet of polished metal as the background of a perspectival set-piece, modelled on a town square, because the cloudy sky defied his logical laws.

Similarly, Alberti, while advocating the perfections of the perspective system, would rapsodize over the beauty of trees and fields. He was unable to see the paradox in being intellectually attracted to an abstract, platonic formula while he was, at the same time, emotionally attached to his physical surroundings. These personal contradictions led to idiosyncracies in his ideas about painting. He invented, for example, a *camera obscura*, a box which cut out surrounding distractions to allow the artist to concentrate on a particular view. This was a naturalistic approach at odds with his perspectival theories. The slight confusion which arose from these uncoordinated aesthetics can be seen in works of about 1460 by Baldovinetti and the Pollaiuolo brothers. They portrayed their native Valdarno with topographical thoroughness, as in the landscapes at the back of Antonio Pollaiuolo's *Martyrdom*

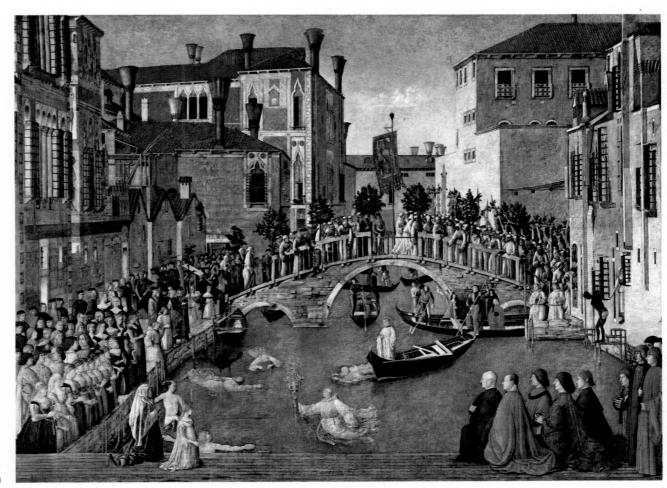

Gentile Bellini: *Miracle of the True Cross at the Ponte San Lorenzo*, 323 × 430cm

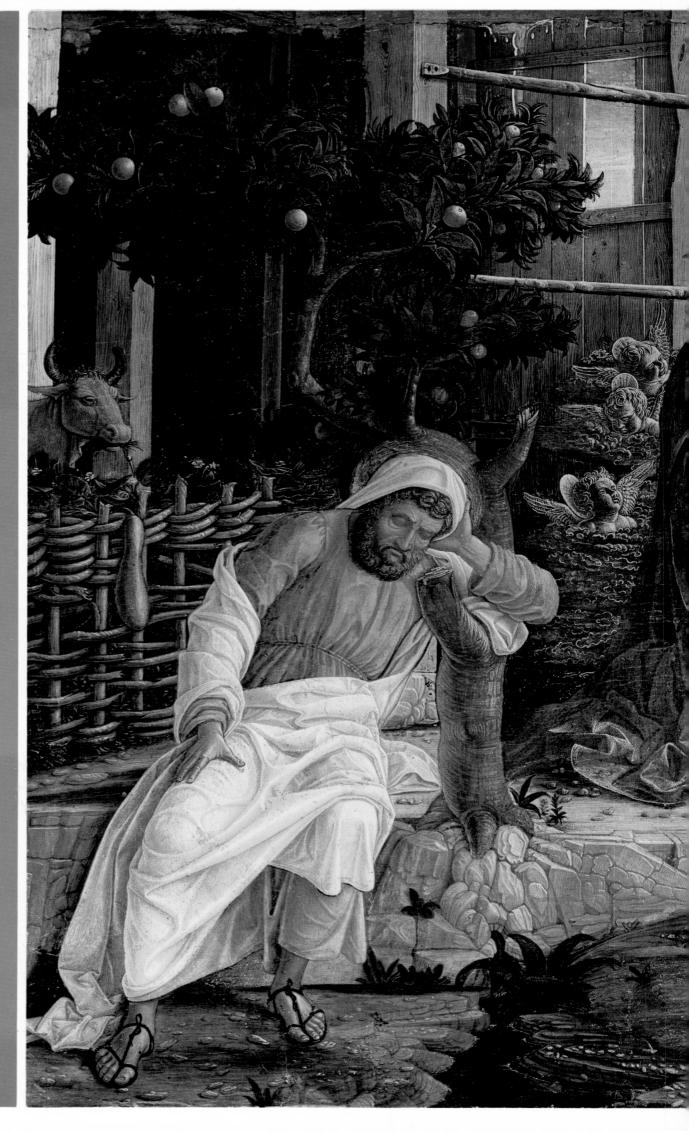

Mantegna (1431-1506): Adoration of the Shepherds, 40×56cm

The sculptural lines dominating this landscape appear all the more remarkable when contrasted with Botticelli's flatter designs, or with Bellini's gentler, atmospheric spaces.

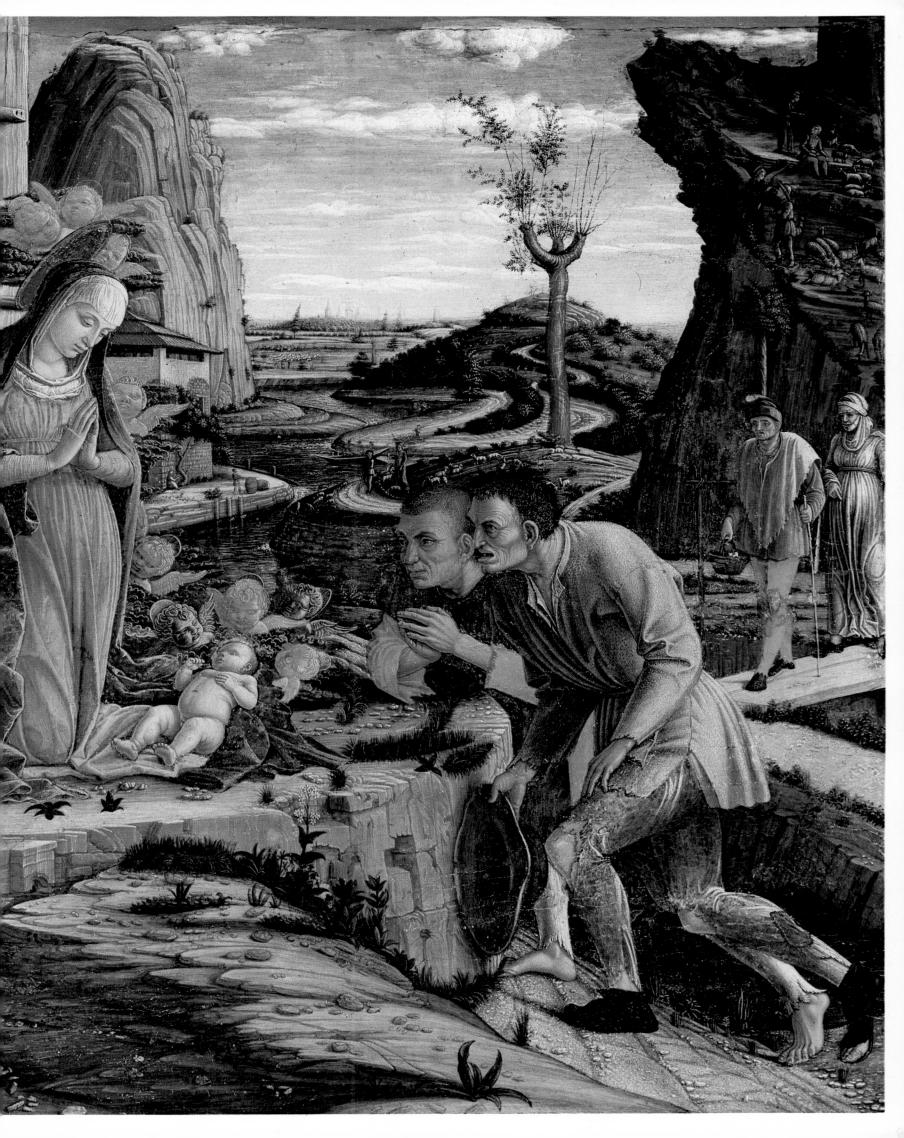

of St. Sebastian and his Rape of Deianira. But his blend of pure science and naturalism makes him jump from one receding plane to another — there is none of the smooth, intuitive transition found in the best Flemish painting.

Piero and perspective

Piero della Francesca responded particularly well to the mathematical challenges of Italian perspective. In the reverse panels of his portraits of the Duke and Duchess of Urbino, he exploited the fact that Brunelleschian perspective would only work when the receding plane was at a right-angle to the picture plane, just as the *camera obscura* could only work from a high viewpoint. Cutting his coat to suit his cloth, he adopted the traditional Flemish device of a view from a high ledge. Piero painted his own softly flowing, Umbrian hills running parallel to the edge of the picture frame, but starting well above it. He had thus cut out the complications of trying to run a foreground into a middle and far distance.

Cool mastery

Piero could manipulate colour to achieve taut effects which might well have been banal in the hands of a lesser master. Thus his choice of a pink garment for a risen Christ in a painting of the Resurrection focuses the pale light of a symbolic dawn, without sinking into sentimentality. Piero is remarkable, above all, for his calm ability to create static, sculptural harmonies. One thing may be measured against another.

In *The Baptism*, for example, the trunk of the tree dominating the composition and the body of Christ beneath it are parallel forces. In this painting (which has a curved top echoing the round shape of the tree top) the straight form of the tree trunk and the similarly pale upright of Christ's body

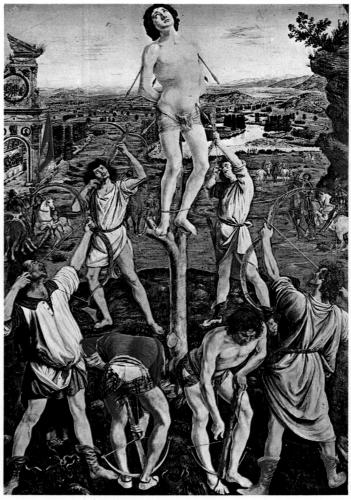

Pollaiuolo: Martyrdom of St. Sebastian, 291×202 cm

Metsys: The Triptych of St. Anne, central panel 225×219 cm, side panels 220×92 cm

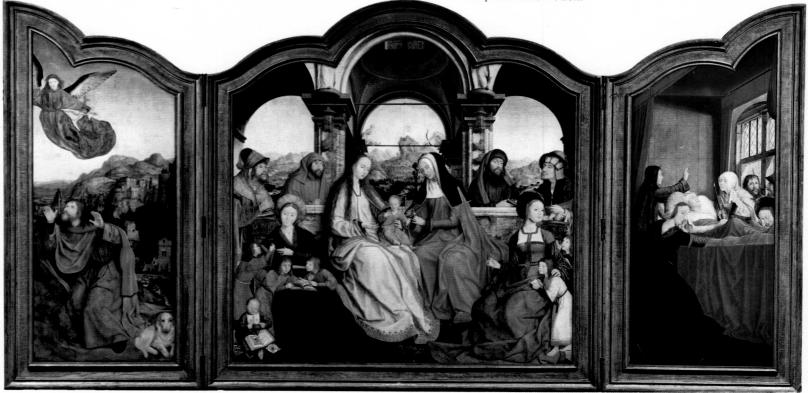

OPPOSITE Metsys: The Triptych of St. Anne (detail of landscape from left panel)

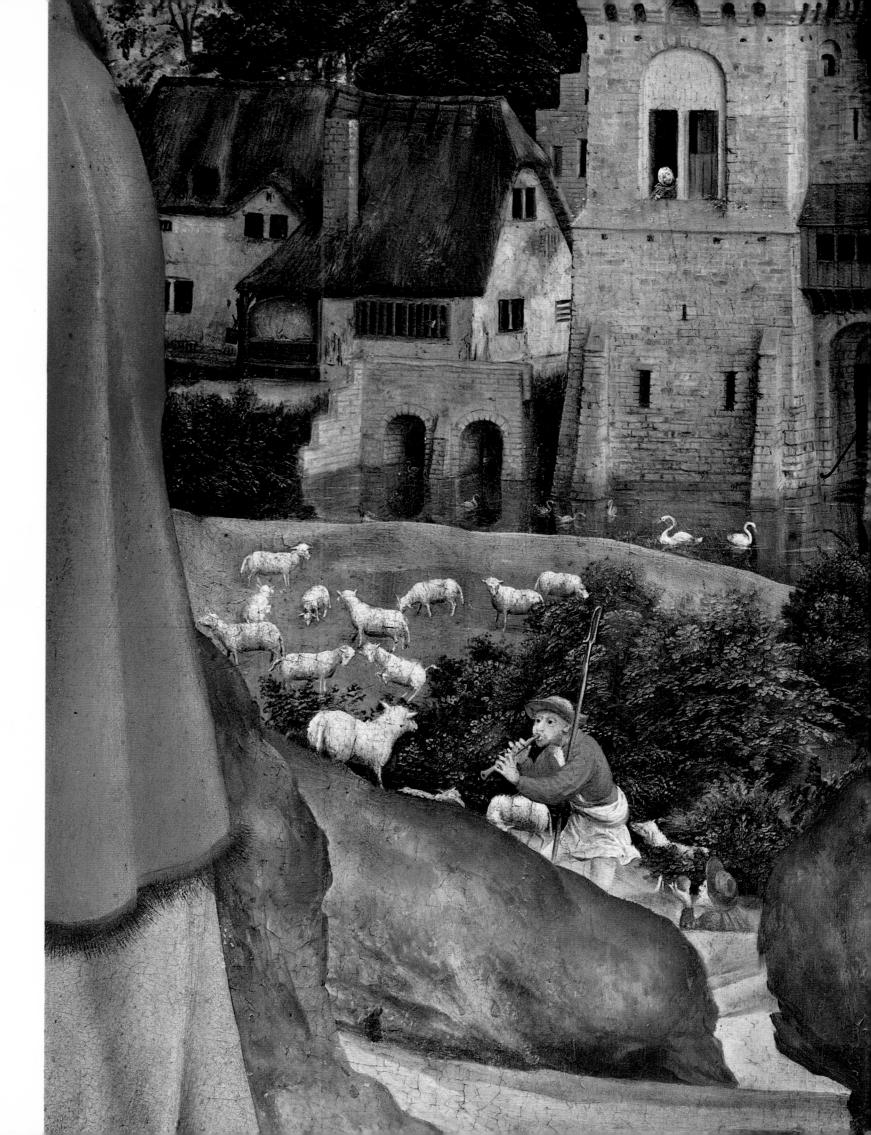

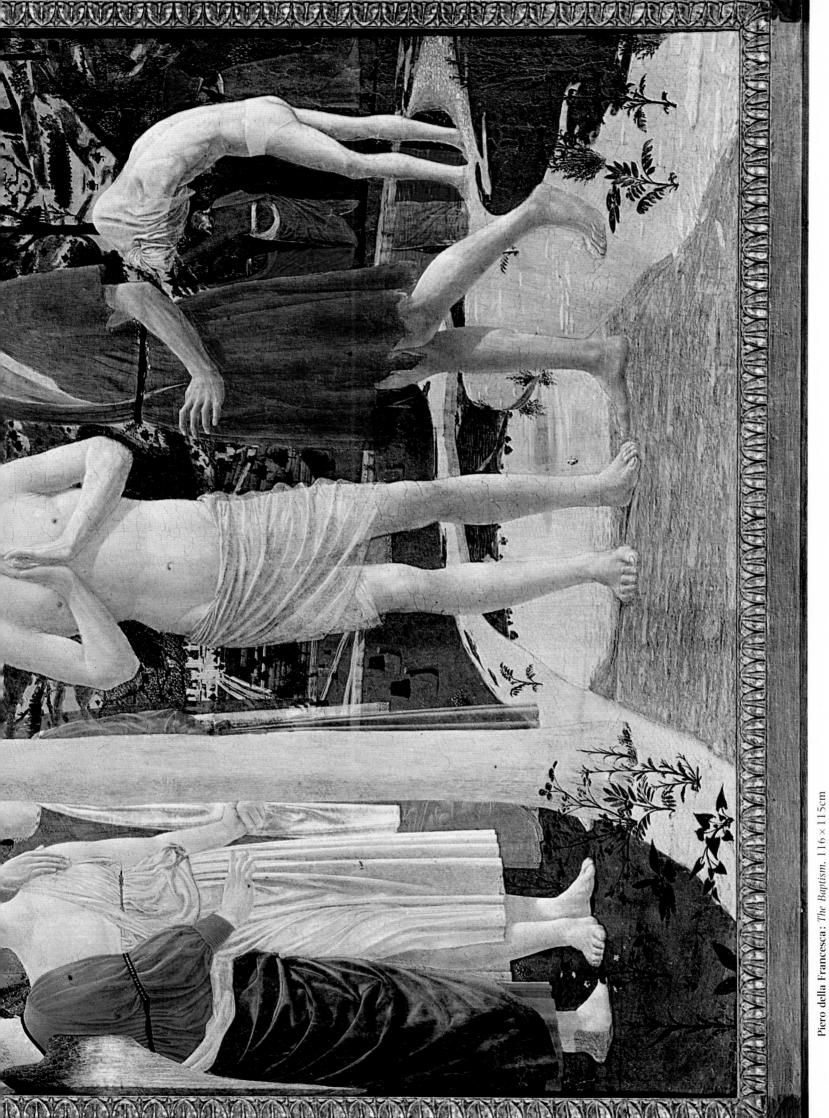

are like two columns. These uprights dominate the composition and, once the eye has taken them in, provide a constant point of reference. They are the modules which dominate the painting. In looking at other parts of this picture one is constantly drawn back to these central pillars, mentally measuring the other figures in the image, or the angles they create, against them.

The painter appears to have indicated a special relationship between Christ and this clearly designed tree which so enhances his composition, making a natural canopy. Piero, in his great painting *The Legend of The True Cross*, had already explored the visual potential of a tree as a symbol of life and source of spiritual power. Given a landscape setting, a tree provides the obvious unit to compare with man. Lacking the fragility of a flower, the massive quality of a mountain or the meandering form of a stream, a tree has firmness of structure and a long life-span.

If one had to pinpoint changing attitudes in landscape painting by discussing a single item, a tree might well prove rewarding. The trees cluttering the land in so many medieval paintings, tucked into blank spaces like so many lollipops (as in works by Lorenzetti), show man taking nature lightly, whereas intense tributes to trees by nineteenth-century painters (such as Caspar David Friedrick) where man is

included as a tentative flea, prove the power of pantheism. With Piero, however, both extremes are held in check. Christ is not dwarfed by this tree — neither does it lose any dignity by being placed in such proximity to a living god. Piero has come a long way from the medieval cartoons in which trees of life, crowded with figures, stagger under their allegorical trimmings. It is Piero's simple control of form, symbolized by the way he treats Christ and this tree as aesthetic equals, which makes for his beautifully balanced picture of the world.

Ut pictura poesis

The master of poetic landscapes, illustrating the theme of *ut pictura poesis*, or, let the picture be like a poem, was undoubtedly Giorgione. Benefiting from Bellini's painterly skill, as well as the kind of imagination which he displayed in works such as the *Allegory of Souls*, Giorgione's paintings reveal what the Venetians called 'poesie'. His paintings are praised, but hard to define. It is in their very ambiguity (like that in Coleridge's *Khubla Khan*) that their attraction lies. Beautifully painted, their slightly incongruous components afford the endless speculation of a clearly remembered but undecipherable dream.

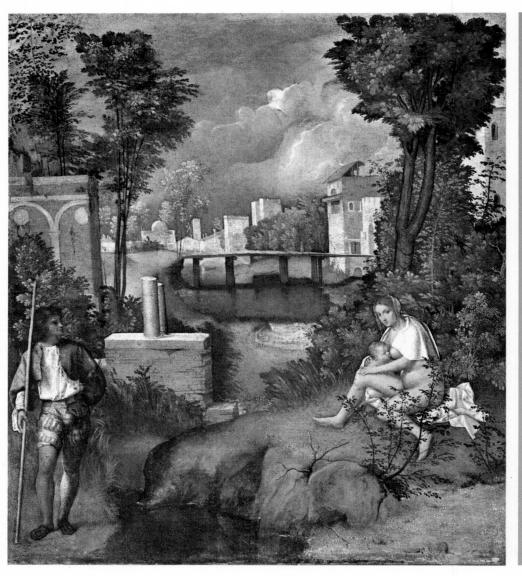

Giorgione (1478–1510): The Tempest, 83×73cm

The ambiguity of this painting is felt by anyone who tries to find a word, or a phrase, to catch its meaning. Neither boisterous nor wistful, it conveys a teasing sense of the mystery of life. It is significant that while we peer into this canvas a woman looks out at us with an expression that distils the wisdom of a contemporary madonna while anticipating the frankness of a nude by Manet.

The soldier's gaze, the two broken columns, the distant buildings having the solidity of old farms, and the fine foliage displayed against pale flesh — distinctive images and metaphors, like these, fuse within this coloured poem which glows with that sensual stillness and surprising quiet before a summer storm.

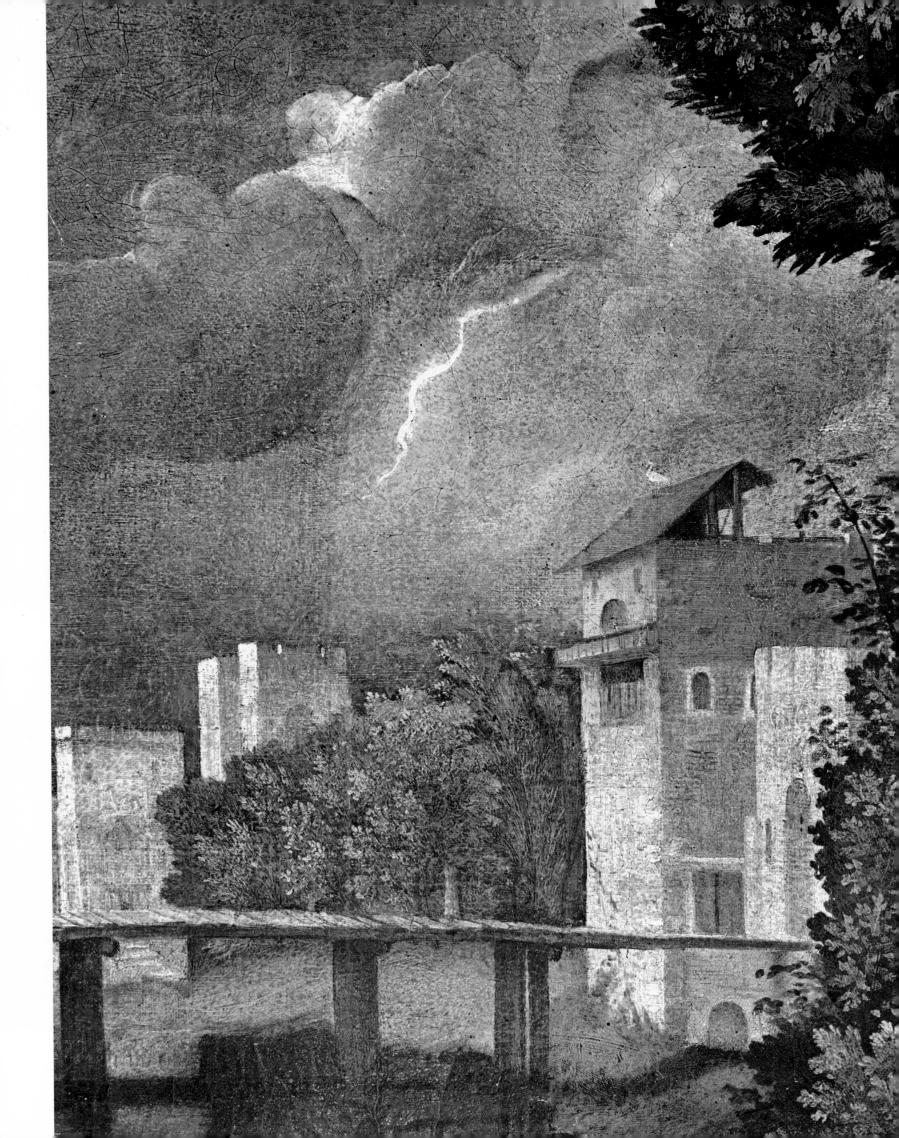

Landscape and the artist

Imaginative paintings, such as those of Giorgine, helped to play a part in the development of the artists' role in society, because they were obviously highly creative. Leonardo, in his influential Treatise on Painting, had advised other artists to be inventive, to look at irregularly coloured stones, stains on walls, clouds and embers in the fire in a speculative way to discover themes, imaginatively speaking, for future paintings of fighting figures, wild expressions, mountainous landscapes. Leonardo was stressing that the artist works with his mind's eye as much as his physical eye, and was trying to get rid of the old idea that artists were mere illustrators or copyists. Painters, like sculptors, had long been reviled as inferior manual workers whose achievements bore no comparison with those of intellectual creators like writers. But in the Renaissance artists deliberately fought to gain recognition as original thinkers, not just as useful craftsmen.

Originally, landscape painting as a genre was low on the scale of academic priorities, and was expected to illustrate moral themes. In addition, the human body was believed by High Renaissance theorists and by Michaelangelo to be the most expressive source of study. But despite this, landscape painting gradually, and almost inevitably, gained kudos. Painters who began, in the Renaissance, to experiment with landscape for its own sake were paving the way for later artists. In the nineteenth century, for example, when the artist finally came into his own as a cultural hero par excellence, extolled in the literature of the time, it is highly significant that his chosen vehicle, more often than not, was landscape painting. It was by painting pure, as opposed to 'ideal' or 'historical', landscapes that he claimed to reveal the divine in nature, portraying himself in an all-powerful prophetic role.

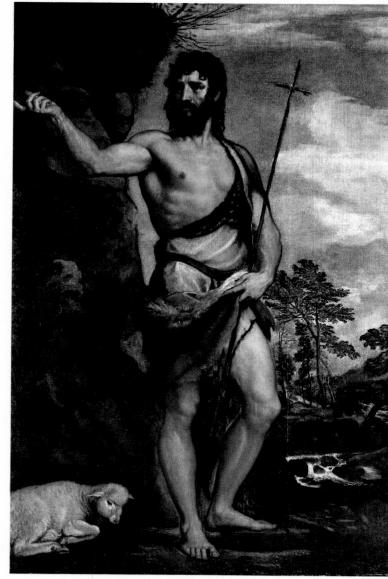

Titian: St. John the Baptist, 201×134 cm

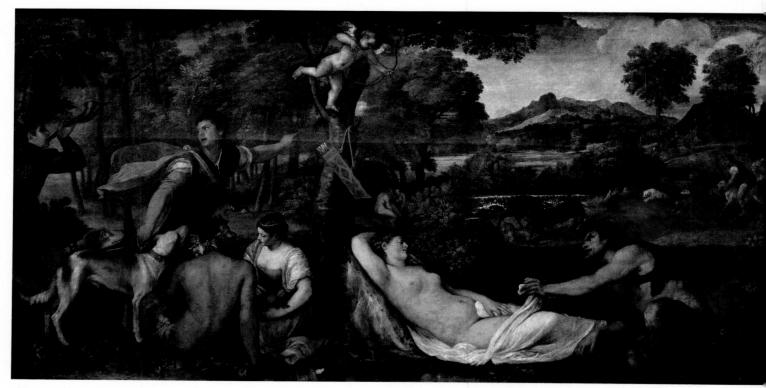

Titian: The Pardo Venus, 196 × 385cm

Giorgione and Titian

The theme of ideal landscape was taken up by Giorgione, inheriting Bellini's painterly skills and love of light and using his master's gifts for lyrical compositions. Giorgione's compositions are sometimes said, as, for example, by the astute art critic Walter Pater, to have a musical quality. There is certainly little of hard logic in their gently finished, almost teasing ambiguity, and it is highly significant that this painter's imaginative ability improved when he came in contact with the so-called 'Arcadian' poets at the court of Caterina Cornaro. Giorgione's distant, elusive sensuality, which pervaded his figures and landscape alike, became not exactly cruder, but certainly more tangible in the hands of his younger contemporary, Titian.

Titian's trees, like his nudes, have a robust and sturdy quality. Seen in comparison with Giorgione's, they appear to have grown straight out of the earth, not out of an idea about the earth. It is hard to pinpoint the difference between these two but it exists as surely as there are cat-lovers and dog-lovers.

Echoes of Titian's landscape vocabulary such as his clumpy trees, rocky hills, rushing streams and vivid blue hills of his native Cadore, reappear in endless landscapes through the ages. It is as though other painters, whatever their current obsessions, could not resist his vivid words and tucked them into their own works, just as a host of writers have slipped fragments from Virgil, Dante or Shakespeare into their own books and plays. The scenery in Titian's *St. Peter Martyr*, for example, was 'quoted' by a whole series of seventeenth-century painters, while still later landscape masters, such as Turner and Constable, also made pictorial references to Titian's visual phraseology. Phrases, rather

than compositions, provided Titian's basic contribution to the development of landscape painting. His sense of tone could be crude and his backgrounds layered like retreating steps, the abrupt blues of his mountains often appearing like the staged colour divisions in commercial paint charts.

Annibale Carracci and Claude Lorraine: derivative and poetic painting

Titian's lesser followers soon fell into the trap of producing stereotyped images, rather than developing their own vision. Annibale Carracci provides an example of someone content to use ready-made devices at the expense of looking for himself. Compare his works with those of Claude Lorraine and they will seem as dull as flat champagne, for Claude was able to use the 'ideal' tradition as a means of expressing his own wonder. We have here one of the vital distinctions between the landscape painters of all time, for while Annibale was easily able to arrange stylized parts into pleasant pictures, his talent remains that of a glorified wall decorator. Claude, on the other hand, defies definition. His paintings can appear superficially naïve (What childish figures!) and endlessly repetitive (What! Another sunset?) but they have a transcendental quality which remains in people's memories even when they have forgotten the exact contents of his paintings. They are ideal, not only in the sense of an art historical category, but also in the wider sense of provoking an illuminating feeling.

Claude's method

Claude's painting profited from his outdoor meditations. Joachim von Sandrart records that Claude would devote himself to contemplating the beauties of the Roman Cam-

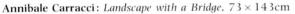

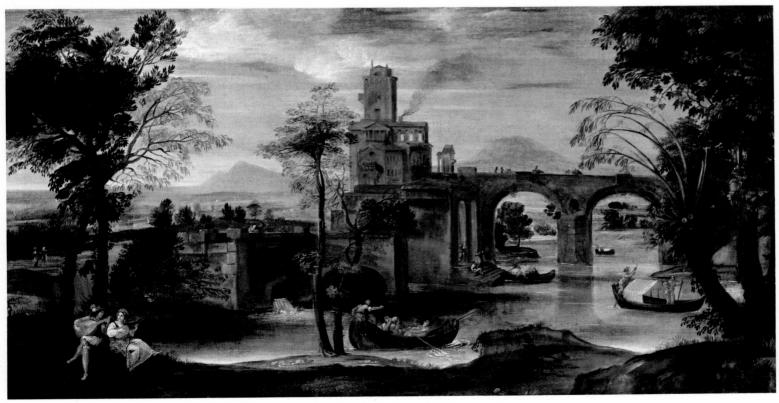

pagna, studying the mysteries of sunrise and sunset. He also drew from nature, producing endless studies of great delicacy, and sketches of light on the land, and always searching for fresh fodder for his grand machines. The next step was to work out his compositional ideas, not expressing them in dry, academic ways, but in the individual forms he found in the countryside. Claude refined what he saw, but his leaves and branches, his hazy skies and lapping lakes, are all based on realistic observation.

In addition to his final drawings, metering his overall disposition of mass and infiltration of detail. Claude painted his far distances from nature. This is a fact setting him apart from the Old Masters, as well as contributing to the finesse with which his horizons slip into the atmosphere. Claude's general pattern was to paint a dark coulisse on one side of a painting, letting its shadow extend across the foreground. In the centre of the middle ground he would place a majestic central feature, such as a group of trees, and behind this, two further planes. His mastery of tone was such that, even when each recession stage was parallel to the last, they appeared to melt into one another, showing off the dark

masses. Claude's grandiose seaports, painted in the 1640s, were surpassed by final works such as his *Times of the Day*, produced when he was over sixty.

Ideal landscape: a healing dream

Considering ideal landscapes, the viewer finds time and time again that these works were connected with the classical past, and the writings of Virgil in particular. Virgil's accounts of shepherds and husbandry, his delicate scenic suggestions, and his praise of innocent rustic life, all added up to a poetic evocation of man living humbly, but harmoniously, in the midst of rural felicity. This was a dream of paradise, and a peaceful dream at that. Sunny, open landscapes personified the kind of Elysian myths which have a healing power in every civilization.

A nostalgic flavour

Ideal landscapes, then, conjured up an optimistic picture of man at ease in his environment, but the fact that this

Claude Lorraine: Embarkation from Ostia, 211 × 145cm

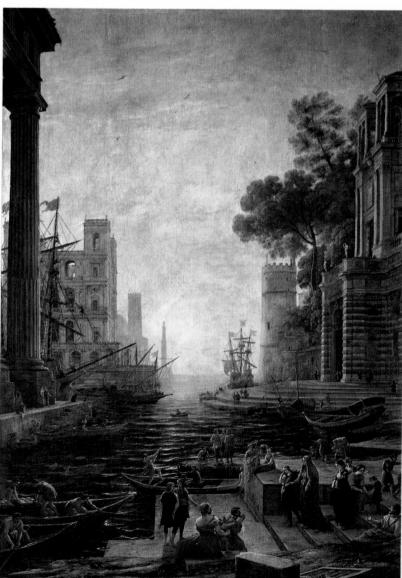

Claude Lorraine: The Archangel Raphael and Tobias, $211 \times 145 cm$

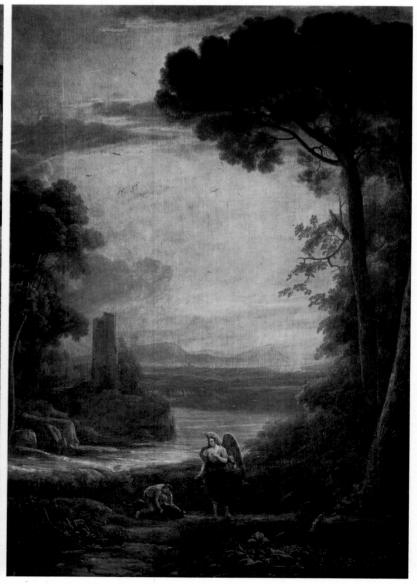

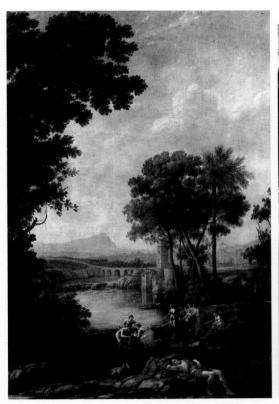

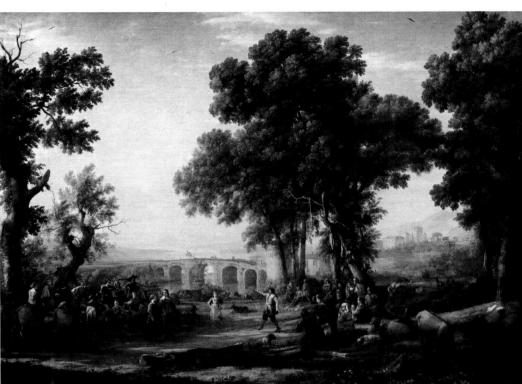

Claude Lorraine: Village Fete, 103 × 135cm

optimism was rooted in the classical past, rather than the living present, gave many compositions a wistful or nostalgic flavour. There were buoyant bucolic pictures in this genre, but the gold of this golden age was often the fading light of sunset.

Claude and Poussin: contrasting temperaments

Claude's paintings profit from artificial devices (such as bridges, moving flocks, and flowing rivers) designed to lead the eye into his illusionary worlds. With him they are an addition, but with Poussin a sheer necessity. Nothing in Poussin was ever careless or casual. Where Claude achieved balance by instinct, Poussin measured it with a ruler. What Claude knew, Poussin proved. They were like the Saint Paul and the Saint Francis of classical painting: Poussin laying down the law, and Claude dissolving it. Claude, if one tries to think of him in other roles, conjures up the poet, the musician, or the tranquil gardener, but Poussin falls into a firmer mould — that of mathematician or engineer.

Poussin's style

Painting landscape provided Poussin with a challenge since the land is flat. He had the problem of establishing verticals to counteract this horizontality. He used not only trees and cliffs but artificial verticals; architectural features supplied his craving for straight lines. Frequently designed as the modules of a painting, these buildings and their masonry subdivisions provide mathematical keys to his constructions. Ruined buildings, in addition, lend an air of grave antiquity suiting his sombre turn of mind. Poussin often places his temples and towns parallel to the picture frame.

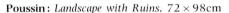

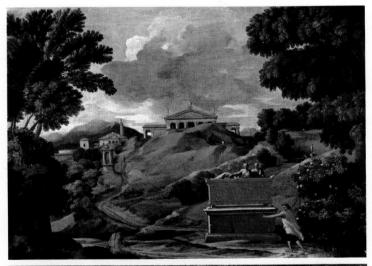

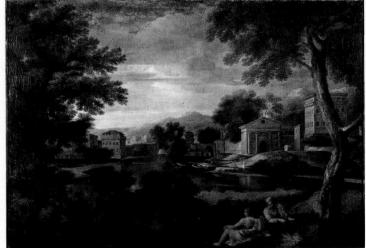

Poussin: Landscape, 72 × 95cm

Landscape Painting: Poussin

Thus the viewer finds himself face to face with Poussin's landscapes: there is no need to search for a mysterious opening in the space before one, everything is plotted out. Becoming accustomed to Poussin's plans, which include occasional instances of central perspective, one learns to trace this master's subtle diagonals by following his cunningly angled paths.

Poussin: nature rebuilt

Nicolas Poussin, a stern Cartesian, did not paint landscapes until about 1648, when he was fifty-four. As he believed, strictly, in the moral character of painting and in intellectual creativity, Poussin enjoyed nature but wanted control of her irregularities. He used her as raw material, making solid scenery where sensible trees appeared to be strongly rooted in the ground, and every building to have firm foundations.

With exceptions, such as his relatively fragile *Spring* or tempestuous *Winter* in the Louvre, his *oeuvre* is always controlled.

With Poussin, the rectangular frame of a painting does not simply surround it, but gives it a logical *raison d'être*. This painter was so addicted to geometry that he conceived of painting as an intellectual exercise in placing verticals and horizontals at right-angles to one another. He spaced them rhythmically, balancing each interval, using the golden section.

Poussin's legacy

The scientific skill with which Poussin arranged his landscapes and then, like a clever criminal, managed to disguise his own masterplan was a sign of his genius; an endless series of painters have profited from his mental framework,

Poussin: Moses Saved from the Bulrushes, 85×121 cm

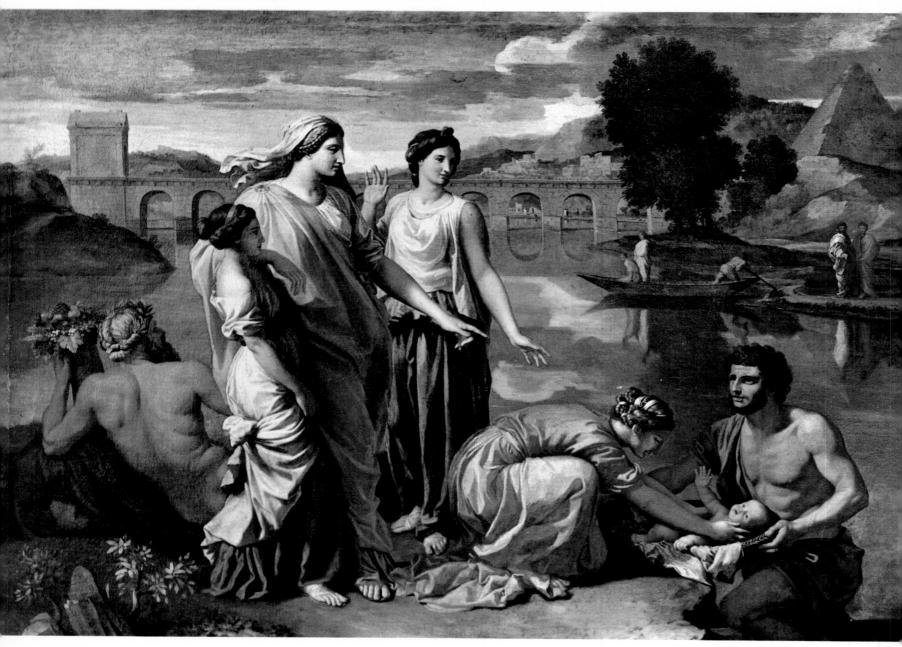

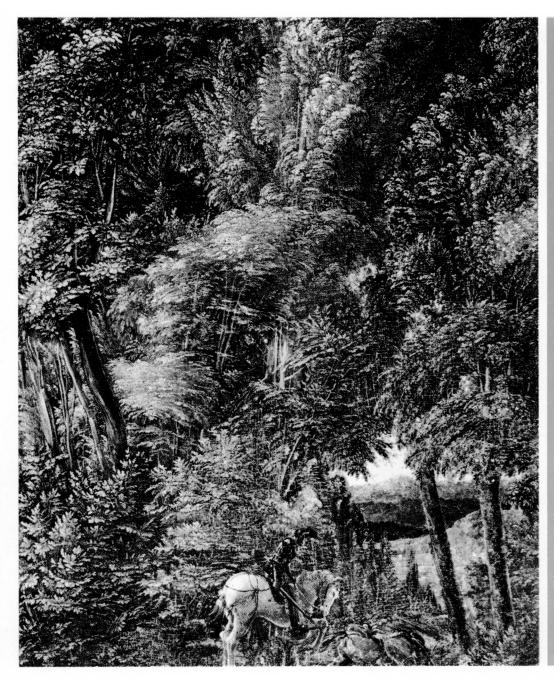

Altdorfer (c.1480–1538): St George, 28×23cm

This painting by Altdorfer is not so much a landscape as a treescape. Trees fill the total area of the picture, fanning up in thick growth like corals on the seabed; branches and leafy fronds make a delicate, organic mass. The sky is only glimpsed, as if by chance, through a ragged opening low down in the right of this impenetrable thicket. This density of foliage, spreading from the bottom of the canvas to the sides, and right up to the very top of the painting is all the more overpowering because of the little figure of St. George submerged in the undergrowth below. Whereas some landscapes were designed to show up or dramatize narrative incidents. this one seems to operate on a different principle. The tiny St. George seems more like a key provided to give scale to the immense trees in Altdorfer's magic forest.

This is an image which reveals many of the basic differences between Northern and Southern landscapes. This romantic subject, and the way in which it has been subjugated to an uncontrolled natural setting, is Northern both in sentiment and presentation.

but none have superceded him. Sébastian Bourdon, Gaspard Dughet, Francisque Millet, Henri de Valenciennes, Corot and Pissarro have all adapted aspects of his work, often taking his plans as the scaffolding for their own works. Even Cézanne, celebrated for redoing Poussin from nature, cannot be said to have surpassed this Old Master: Cézanne's achievement is very much on one plane, whereas Poussin's productions exist on a series of levels – philosophical, spiritual and aesthetic. Similarly, the paintings of Piet Mondrian provide a pathetic caricature of Poussin's achievement: for the earlier artist's theories on the way to represent tragic and comic events are logical exercises of the highest order. Within an individual painting he repeats and varies a selected group of shapes, lines, colours, and tones with the dedication of a great composer evoking the music of the spheres. Poussin, the arch-classicist, provides the perfect stepping stone for a study of Northern Romanticism.

Romanticism versus Classicism

The most rewarding 'Classical', or 'Romantic' artist incorporates intuitive or objective measures from the opposing school, rather than reacting strictly to type. The terms 'Romanticism' and 'Classicism' do, however, provide useful categories when plotting an artist's particular leanings. Geographically speaking, Romanticism is a Northern extreme, Classicism a Southern one. In considering the difference, say, between the countries of the southern Mediterranean and those of northern Scandinavia, one becomes aware of the inherent differences in these attitudes. Imagine the difference not only in heat but in light between Africa and Iceland: in the far North winters are long, dark and depressing, while brief, luminous summers provoke ecstatic relief. Moods are closely bound up with fire, light and seasonal change, and Northern painters reflect their environment by producing

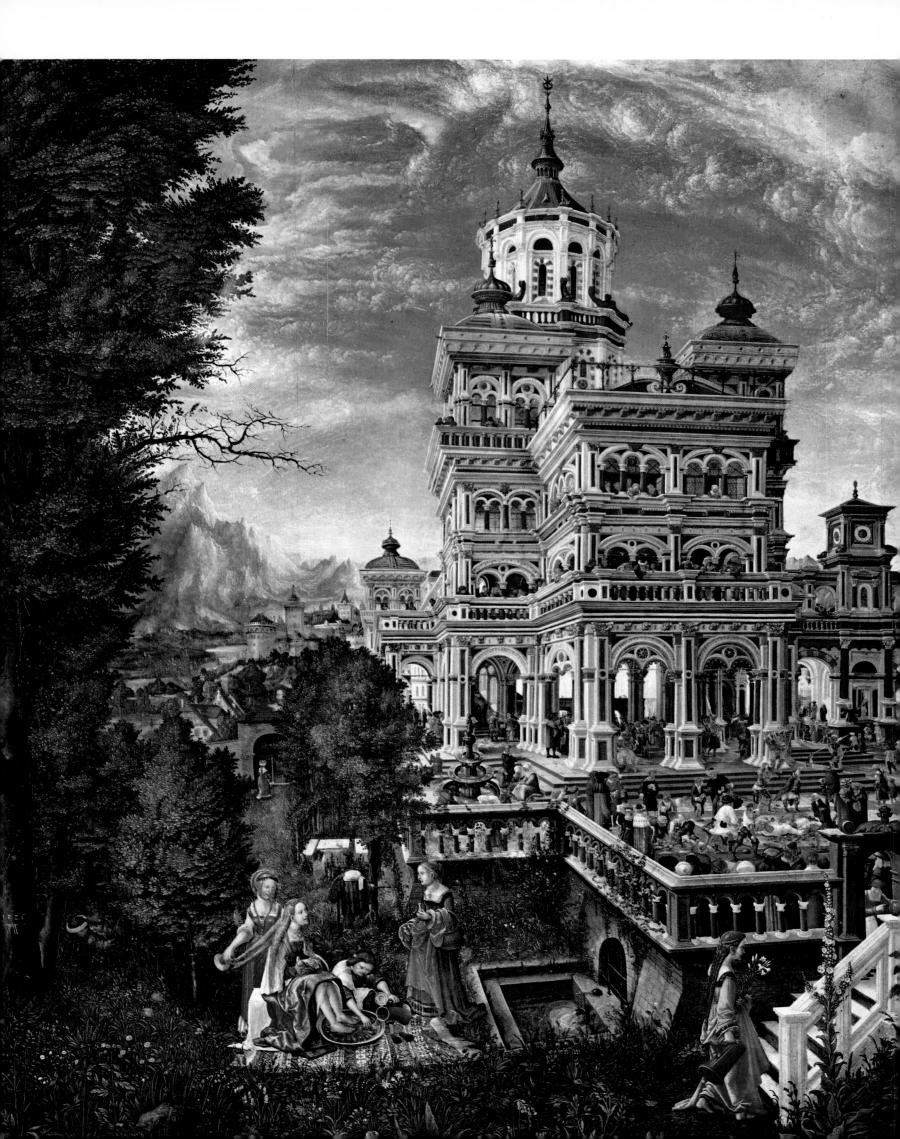

OPPOSITE Altdorfer: Suzanna and the Elders, 75 × 61 cm

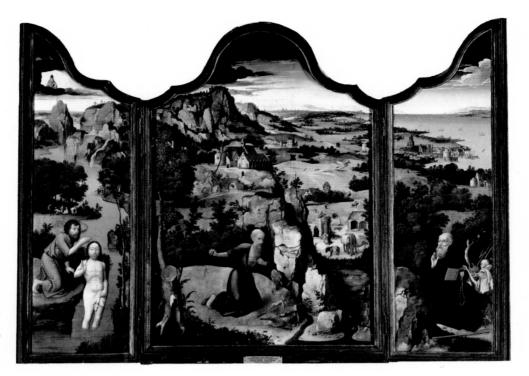

Patinir: The Penitence of St. Jerome, central panel, 120×81 cm, side panels 122×37 cm

images from their subconscious minds: reflecting the power of the elements as much as of the intellect.

The Northern tradition

The dark woods and Gothic motifs of Altdorfer, the slimy twigs of Grünewald, and the obscene concoctions of Bosch could never have come from the dry South. The works of the latter artist, in particular, anticipate Goethe's cynical remark that classicism is health, romanticism illness. His expressionist images (expressed in hair-fine, knife-edge, egg-smooth perfection), such as hell-fires in the dark, later inspired the neurotic Piero de Cosimo, put interest into Patinir's prosaic landscapes, and reappeared in Giorgione's imaginative dreams.

Hybrids

Much of the interest in European landscape stems, in this way, from ideas moving from North to South. Artists travelling from Germany to Italy, blended Northern and Southern

themes, creating new aesthetic species. Adam Elsheimer provides a perfect example of this kind of cross-pollination. He brought the seeds of Northern thought to Rome in 1600, painting in the current classical style but retaining his own Northern feelings about light, and its atmospheric possibilities. His intuitive appreciation of light later took root in the works of Claude Lorraine.

Bruegel: Northern perfection

Where Bellini portrayed the South with simple love. Bruegel distilled the flavour of the North. Born after Bosch, he moved away from the latter's fantasies towards a more direct appreciation of human life and landscape. His trees and fields are exact, and although he adapts the theatrical frameworks of the Mannerist tradition his paintings leave a final impression of nature observed. Like Shakespeare, he could include a wealth of tiny details and rustic episodes in his huge panoramas, enriching them without hindering his overall design. Working at times from proverbs and allegories he learnt to lay out scenes of vast social as well as purely

Piero della Cosimo: Venus, Mars and Cupid, 72 × 182cm

Landscape Painting: Bruegel the Younger · Patinir

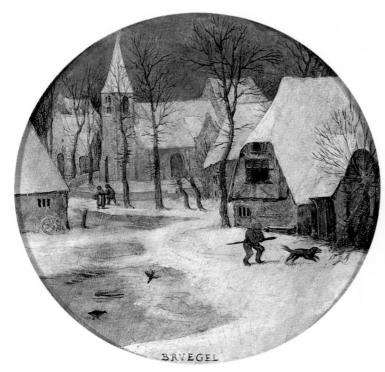

Bruegel the Younger: The Village, 15cm diameter

aesthetic worth. Fulfilling the promise of the Books of Hours, he showed man an integral part of his environment. Winter, with Bruegel, is a composite theme: thus the viewer is unable to contemplate the precision of his December trees for long without becoming aware of the peasants beneath them, and their urgent need for firewood.

Where Bosch illustrated subconscious phobias. Bruegel

captured archetypal actions; his peasants enact the occupations of the seasons; apparently naturalistic events are shown with underlying subtlety. Bruegel's theories about the cosmos often led him to work in spherical patterns which, like planetary formations, included a series of smaller curves and circles (like the hoops and balls of children playing), the pure thought behind these disarmingly simple compositions giving them a permanent value.

Patinir (d.1524): Charon's Boat, 64×103cm

This is a symbolic painting. Patinir, in illustrating this classical myth of the after life, develops a Christian contrast between heaven and hell, complete with suitable angelic forms and roasting fires. Heaven (with the pale water) is on the left, hell (with the dark smoke) is on the right. There is a primitive simplicity here - the river Styx dividing the image into two equal portions. Within this ribbon of water, Charon occupies a central position, like the pivot of a balance. The fact that his boat is painted as though moving down the centre of the river, rather than crossing from side to side, adds to the poise of this composition in which neither landscape is allowed to dominate its counterpart. Patinir has, in fact, cleverly manipulated areas of light and shade, and the curves and notches of his river banks, so that each device has its counter balance on the opposite shore. This sense of one piece jigsawing into another is all the more obvious if, ignoring its symbolic content, one looks at the painting upside down, appreciating its sense of pattern.

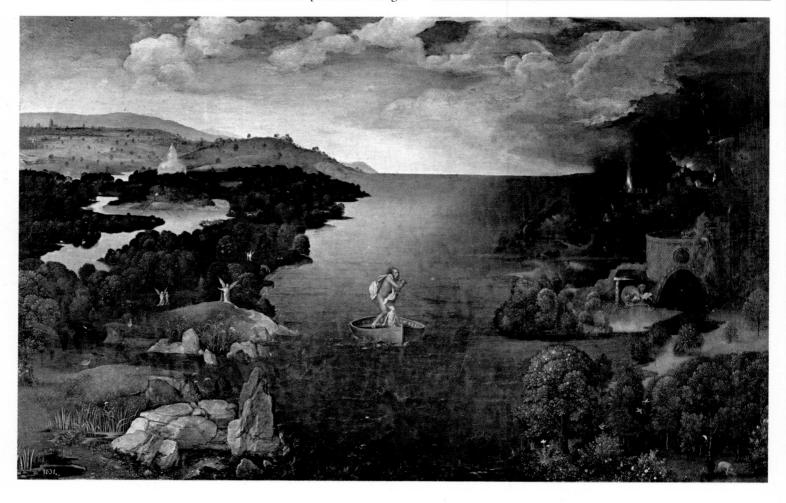

Hieronymus Bosch (1450-1516): Garden of Earthly Delights (left panel and central panel)

Do you delight in this landscape? Or do you find it quaint, curious and perhaps a little unnerving? Although many of Bosch's spiritual themes were bought by Philip II of Spain, a man known for his religious faith, this painter's religious imagery may still strike us as odd. One could argue that whereas a fifteenth-century viewer might have been able to decipher all the superficial allegorical meanings in a picture by Bosch, a beady-eyed modern viewer might be more intuitively in tune with his underlying psychological state.

In this example, Bosch is illustrating a paradise theme with relative innocence. Do you, all the same, read this as an inspiring and whole-heartedly optimistic theme? Or are these the fragile, subconscious whims of a fantasist? What, for example, would he have christened this fantastical invention if he had lived in an age of religious toleration? Do such questions matter? What does remain certain is that this artist's flawless technique, vivid imagination and devious visual wit merit attention and provoke speculation.

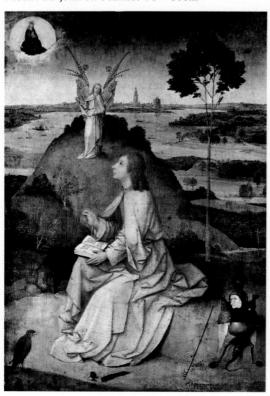

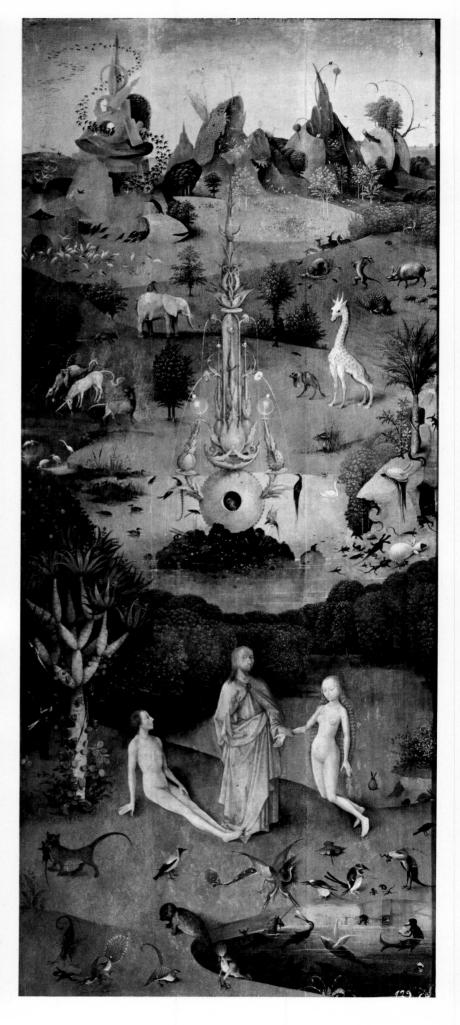

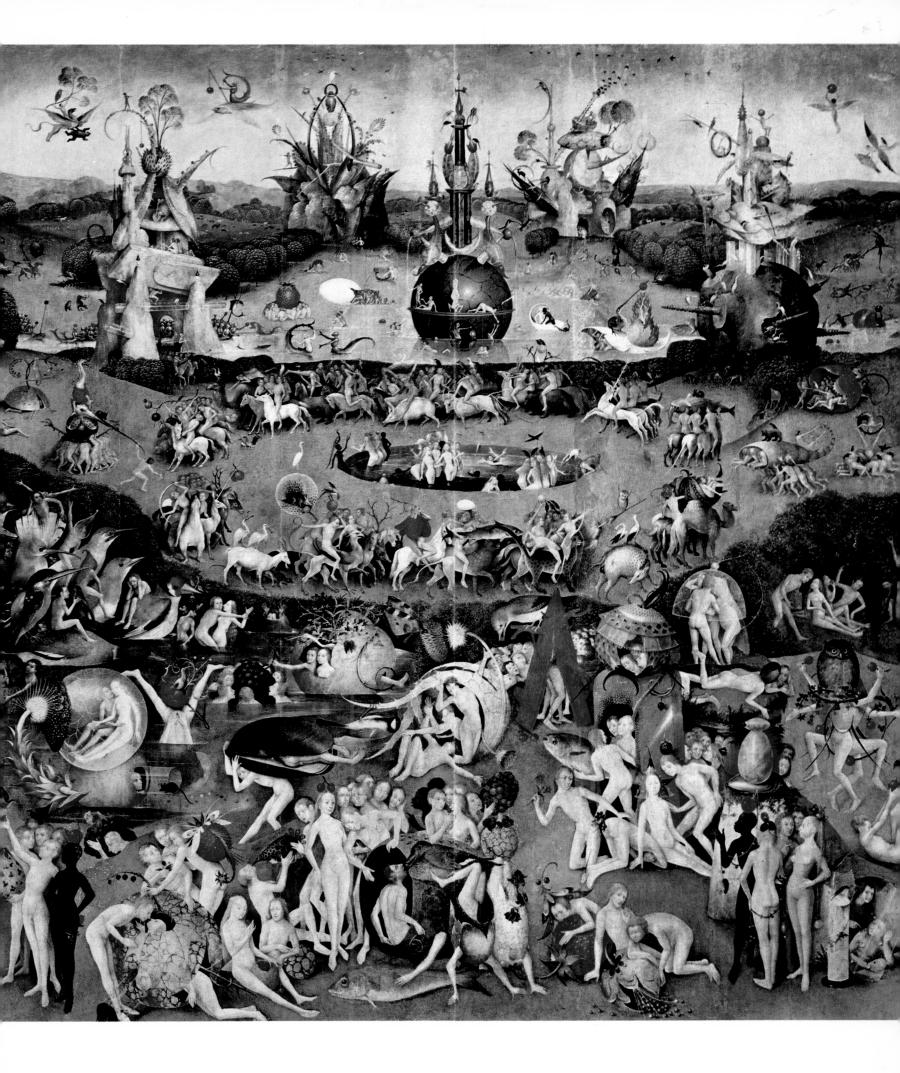

Landscape Painting: Bruegel the Elder

The Fall of Icarus is an ironic masterpiece. Bruegel, like many others, has taken a story from Ovid – in this case the tale of how Icarus, fitted with wings by his father, Daedalus, fell out of the sky on flying too close to the sun, whose rays melted the wax attaching his wings to his body and caused him to plummet down to his death. But instead of concentrating on the falling figure (the obvious solution) Bruegel has deliberately played down the extraordinary elements of the story - making the figure of Icarus seem an incidental detail within the larger panorama of his landscape. This is painted with such care and clarity that the different elements making up the scene vie for our attention. The clear sunny sea in the distance and the sharp, regular ridges of the ploughed field in the foreground are a delight in themselves. while the fate of Icarus (as Auden's poem 'Musée des beaux arts' suggests) is irrelevant in the context of this crisp section of sea, land and sky, all charged with such taut beauty.

Indeed, Bruegel's decision to include a solid ploughman and a series of sailing ships within his wide view also serves to detract from the potential impact of Icarus's fall. The ploughman is so placed that he is unaware of what is happening and will presumably continue with his uncompleted work, and the ships are too far away to take any part in the drama. The peculiarity of this picture is heightened, to a large extent, by the visual stillness typified by its bright, clear sky. For although it is obvious that the ploughman is ploughing, the ships sailing, and the man falling, there is no sensation of movement, but rather one of detached calm. The disconnected way in which incidents are shown may indicate the influence of Bosch, whose compositions often included crystalline, but isolated, episodes. To appreciate the restraint in Bruegel's painting, imagine the same subject attempted by a Baroque artist using, for example, swirling lines to connect different parts of the scene, with Icarus

opposite. Above Bruegel the Elder: The Fall of Icarus, 74×112 cm opposite. Below Bruegel the Elder: Haymaking, 117×161 cm

Bruegel the Elder: Hunters in the Snow. 117 × 162cm

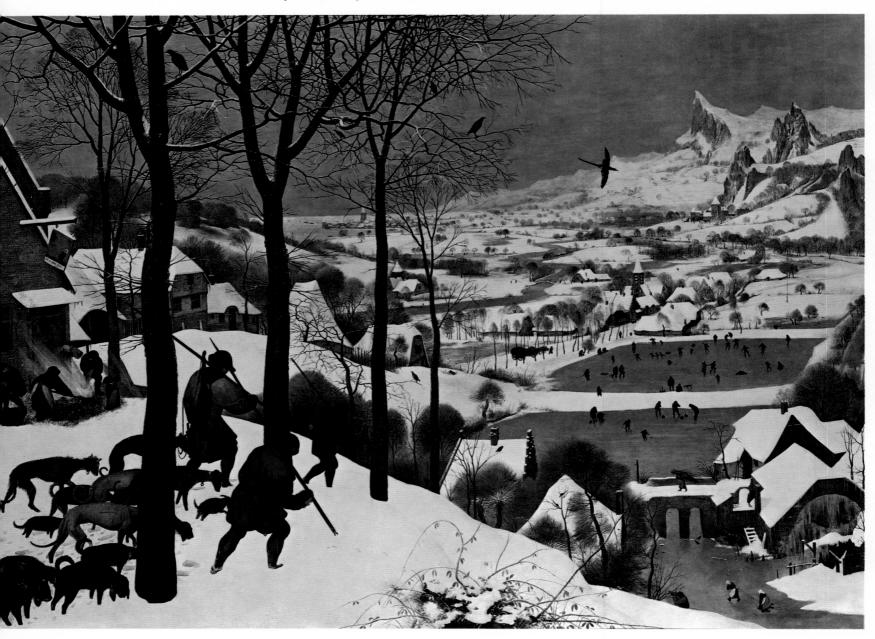

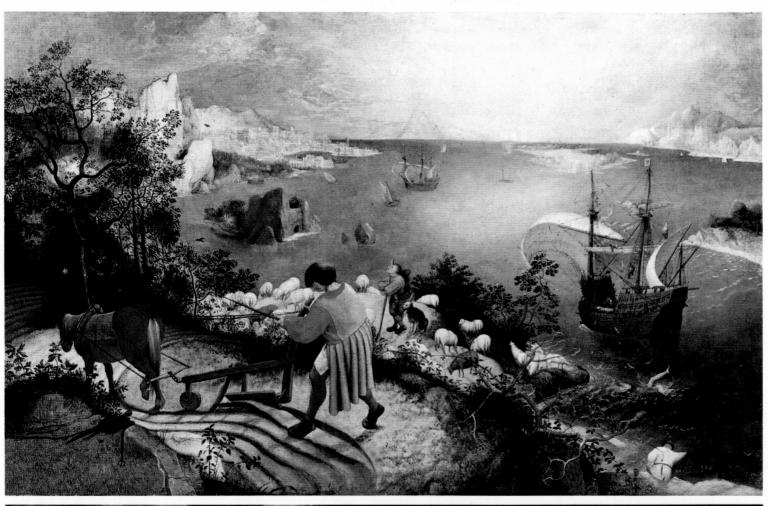

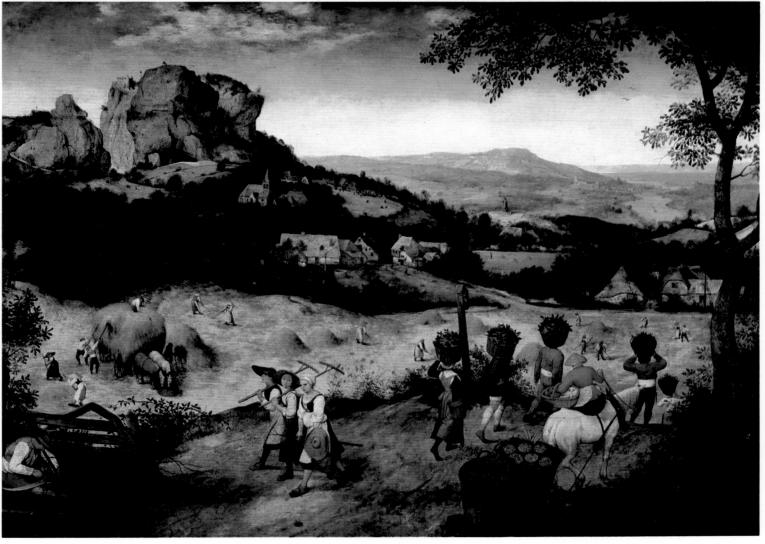

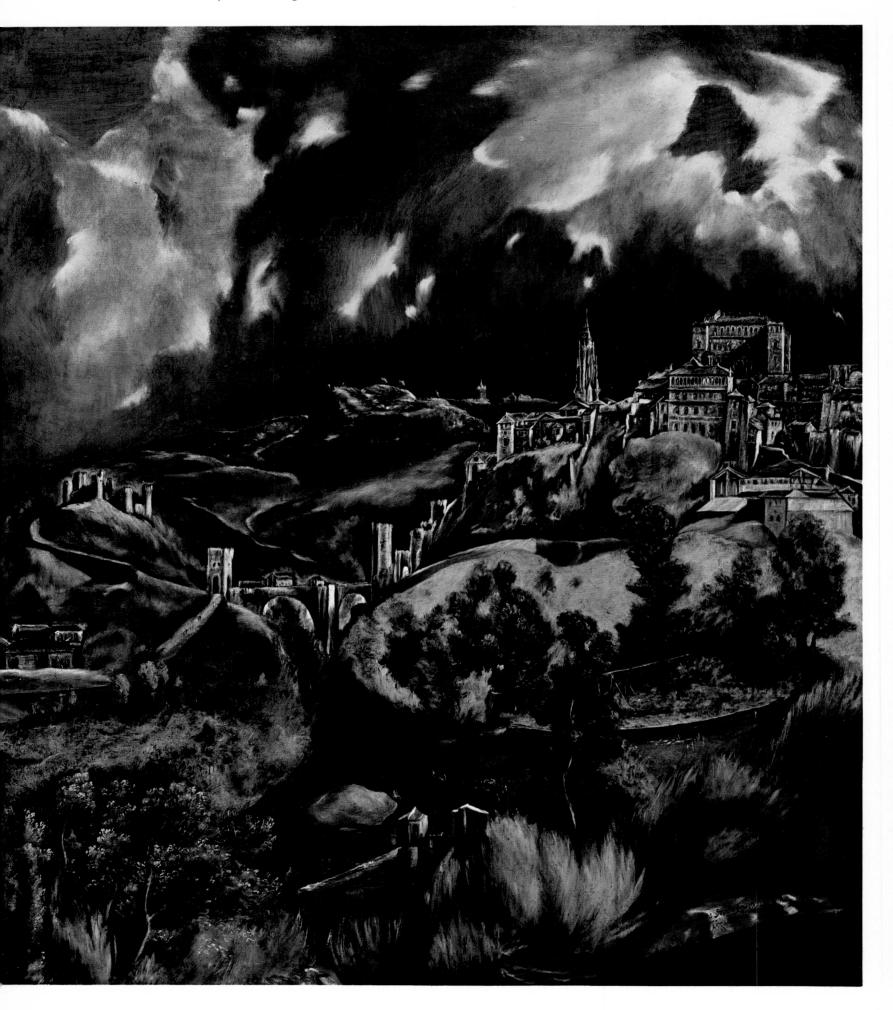

Claude Lorraine: Villa in the Roman Campagna, $69 \times 91 cm$

plummetting down in a vortex of light, his garments rent by the force of his descent. Bruegel's cool achievement, however, derives from his static, cynically detached treatment of this theme. Here, a human tragedy is literally, and hence psychologically, dwarfed by a landscape of surprising skill, whose brilliant, hard-edged colours, enamelled sea and sky, suggest that the earth has a hard, permanent vitality existing regardless of any temporary melodrama.

Mannerism: a historical reaction to the Renaissance

Although many Mannerist painters incorporated classical devices in their paintings, their manner of using them was at odds with the restraint of the classical tradition. For the Mannerists' love of visual excitement belongs, in essence, to the Gothic tradition. Furthermore, imbalance and oddity triumphed over more peaceful harmonies. Everything was for effect. After looking at a series of Renaissance paintings.

Mannerist ones seem like exercises in exaggeration – like so many clever virtuoso pieces in which talented artists have demonstrated their facility to improvise, rather than their power to perfect. The artist's eye was likely to be turned on his own fantasies or focused directly on his audience, thereby securing a dramatic effect at all costs. The living world of landscape, which artists like Bellini had absorbed with thoughtful patience, was reduced to a secondary factor. It is true that certain great Mannerists, such as Rubens, could capture the curl of a bramble or the light of a rainbow to perfection, but for the most part details like these were merged in such grandiose productions that they often lost their individual authenticity. With a Renaissance landscapist, such as Bellini, even the tiniest pebble exists in its own right, but with a Mannerist, such as Tintoretto, it is more likely to be a minute blob contributing to some vast

A typical Mannerist formula, in landscapes, was a high

El Greco (1541-1614): View of Toledo, 121×109cm

Compare this cloudy sky with the calm, pure skies in High Renaissance works, or the quiet glow characterizing a Claude Lorraine. There is something troubled and unnatural here — the light gleaming behind El Greco's marbled clouds is fitful, tortured and sporadic. This is truly Mannerist painting in that it is tense and artificial, without the more boisterous energy of the later Baroque, or more decorative tendencies of the Rococo period. Mannerism, here, is still in its neurotic infancy. This warped landscape and discordant sky provide the natural counterparts to the elongated bodies and harsh, shot-silk draperies characterizing Mannerist figure painting. They are equally unnatural.

If one could concentrate on this landscape to the extent of being transported into its reality, following the movements of *Alice in Wonderland* or *Alice*

Through the Looking Glass, one would be in for a few surprises. Ordinary rules would no longer apply. The earth, with its slippery, seal-like quality might heave or split, while these leaden, light-lined, clouds might break to reveal a hideous vision. But weird as this image undoubtedly is, its value rests not only on El Greco's originality but his ability to remain true to his own peculiar rules: this composition is sustained and governed by the same aesthetic tensions throughout. They have nothing to do with factual, or indeed with practical knowledge. Consequently, while this image might well inspire a whole series of operatic sets, it would hardly be issued to a budding topographer, or a spy about to risk his life in the area. The information contained in this 'view' is purely emotional: Toledo, and its environs, are portrayed with subjective intensity: space and weight, in El Greco's hands, become so much elastic.

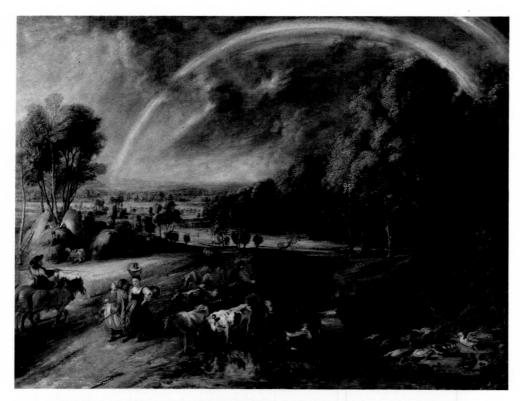

Rubens: *Landscape with a Rainbow*, 94×123 cm

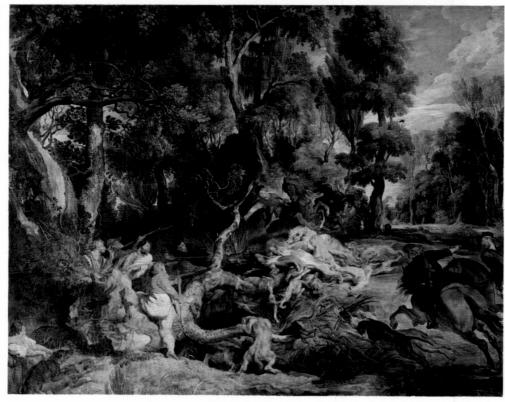

Rubens: *The Wild Boar Hunt*, 137×168 cm

viewpoint taking in a range of craggy mountains with a distant prospect of a river and of the sea as well. This sense of size, scale and drama, such an integral part of the Baroque tradition, was caught in Mannerist landscapes which verge on the absurd in their absolute determination to eschew the ordinary, everyday facets of life.

The Counter-Reformation

The Catholic church's steady hold over European thinking in the Middle Ages resulted in the landscape symbols. Its hierarchial spiritualism was then questioned by the Protestant Reformation movement, a historical event reflected in a wave of direct and unpretentious painting. Then the Reformation was challenged, in turn, by the Counter–Reformation — a Catholic rearguard action determined to win back converts with all the pomp and fireworks it could muster: miracles were brought to life. The Counter–Reformation, directed from the Vatican, pushed artists to work in stupendous rather than factual terms because this suited their advertising campaign.

Just as the formal, perspectival plans behind many Renaissance landscapes can be clarified by an account of Brunellichi's impersonal rendering of an ideal city, so the emotive and theatrical aspects of Mannerist landscape are revealed by parallels with Bernini's St. Theresa Chapel. In this Chapel,

Bernini created a three dimensional picture to convince worshippers that they were in the presence of a supernatural event. He designed this Chapel like a cosmic theatre, with carved images of the donors looking on from either side. Bernini worked upwards, varying his colours and materials through a series of visual stages, thus ingeniously indicating the symbolic climb from earth to heaven. The dark floor, complete with inlaid indications of bones represents the ground, while a coloured marble on the walls suggests rising bands of vegetation. High up, above the altar, apparently floating on a white cloud, St. Theresa appears to have just been pierced, or to be about to be pierced, by the lance of a cupid, and higher still, painted clouds overlap a painted sky. The most remarkable aspect of this elaborate environmental structure is its psychological ambiguity - as in the action described, the blend of sensual pain and pleasure on St. Theresa's face, and the fact that she appears to defy gravity, by being suspended between heaven and earth. The main props in this celestial landscape, carved marble clouds, indicate the character of this peculiar aesthetic drama. Not only do they display a virtuoso brilliance which made heavy stone seem light, but are cunningly lit from a concealed window whose yellow glass gives them an unearthly glow.

Rubens (1577–1640): The Judgement of Paris, 145×194cm

Rubens' landscapes have one thing in common, exuberance. There is never the feeling, with this artist, that he would rather have tackled something smaller, or easier. He was not the kind of man to paint trees in summer, because he was a little weak on branches, or long grass because it covered up his horses' hooves. Rubens, on the contrary, was an aesthetic extrovert, attacking everything that came his way with growing gusto. (What, given the film age, would Rubens have made of Hollywood? His easy treatment of epic themes might well have brought cultural commitment and box office sales into a most profitable partnership.) His own larger-than-life personality, which secured him the respect of Kings, and the devotion of his family, bursts into his pictures.

In his landscapes one can find both naturalistic observation, highlighting the transient beauty of nature — a rainbow by Rubens, for example, anticipates Turner's aetherial studies — as well as full flights of romantic escapism, such as his medieval joust before a castle walls. His own country property at Steen stimulated some of his surest, final symphonies.

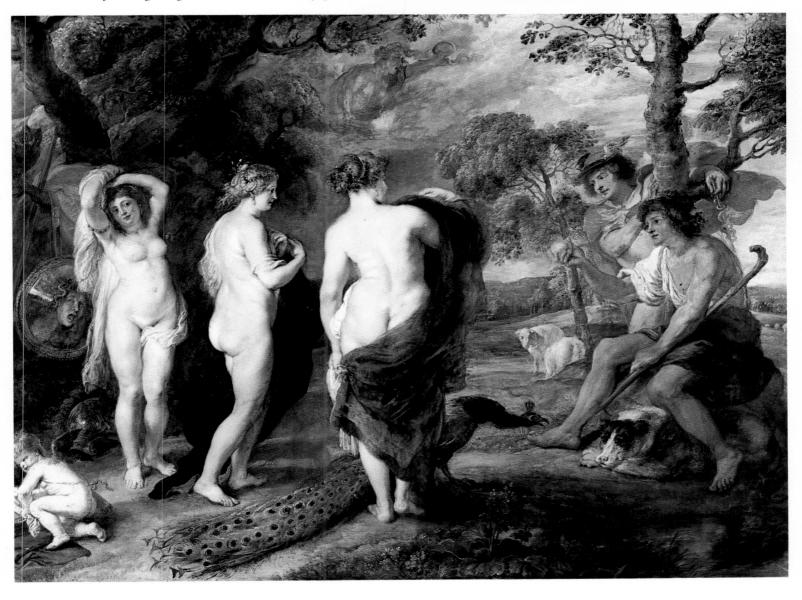

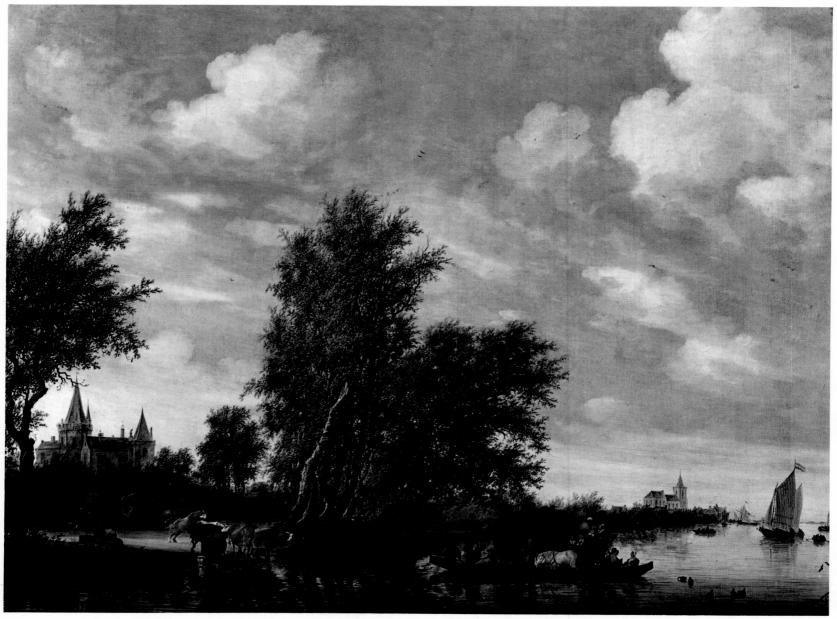

Salomon van Ruysdael: The Ferry Boat, 100 × 133cm

Dutch naturalism: the pendulum swings again

Out of the tired artificiality of Mannerist painting came a new attitude towards landscape painting. Dutch painters began to move towards a new naturalism, unhampered by literary or narrative overtones. The drama in these paintings is one of light. No longer employed to saturate a canvas (as in Bellini's works), it activated the canvas instead, vast patches of light setting off patches of shade. Rather than planning views intellectually. Dutch naturalists concentrated on a faithful representation of what they saw. Where so many landscapists had studied nature for preliminary sketches, or individual elements to incorporate in finished paintings, this unassuming commitment to landscape for its own sake by a group of painters was novel indeed.

The sociological background

Holland, in the seventeenth century, was a rich, Protestant state. Old paintings of Dutch interiors indicate just how fond the Dutch were of pictures, and of realistic paintings in particular. They were an unpretentious hard-working people who wanted down-to-earth images reflecting their way of

life. Realistic portraits and recognizable landscapes were the splendid fruits of this bourgeois culture, which found realism reassuring. Holland was bourgeois in a positive sense and, having recently defended its ethics and its possessions in political and religious disputes, had good reason to be proud of its land and its people. The love of facts and the sharp observation which had earlier characterized the artists of the Netherlands now came to the fore. Significantly, this was also a time of scientific enquiry. The Dutch felt secure and were also interested in the world around them. If one compares these paintings with those from a later, more decadent era, their realism is unmistakable.

Think, for example, of an escapist, Rococco work by Watteau, painted well within the eighteenth century, when the French court was urgently artificial, and you will appreciate the comparative sincerity of this kind of Dutch painting. It is a school characterized by honesty.

Native scenery

The geography of Holland is captured for all time in many seventeenth-century paintings because the painters observed their country with respect. They were moving away from Mannerism, which had taught them to combine weird and wonderful atmospheric effects, linking twisted rocks. blasted trees and acid skies to amaze and stimulate the viewers. Not so the naturalists. The difference between these two styles is like that between plain and fancy cooks, and their failures show the same tendencies. Trivial Mannerist works are nauseously overflavoured, while lesser works from the naturalists are boring in the extreme. At their best, however, Dutch landscapists produced a timeless tribute to their Northern birthplace, evoking her flat plains and low skies with careful observation. Content with little — a few dusty sand dunes against a pearly sky, or an old oak beside a grassy path — they worked with modesty and a pleasant belief in the value of simple scenes.

Rembrandt(?): The Mill, 87.5×105.5 cm

Variations

Esias van der Velde and Jan van Goyen (who learned naturalism by observing the sky) developed realistic styles from about 1615 (although some Dutch artists, such as Pynacker, Asselyn and Berchem, maintained stylistic contacts with the South). The mature van Goyen, Solomon van Ruysdael, Jacob van Ruisdael, de Koninck, Cuyp and Hobbema also contributed to the naturalist movement. Within the period of this naturalist movement there were obvious variations – Hercules Segher's mountain prospect in the Uffizi is a landscape of fantasy, but his drawings and etchings of the Dutch countryside later inspired Hobbema and de Koninck to paint characteristically flat Dutch panoramas. Similarly, Rembrandt (whose landscape drawings of 1650 indicate that he had no problems with light and space) adapted what he saw to make ideal landscapes of sombre force. Classical principles were seen in townscapes by De Hooch, Ter Borch, Metsu and Steen and in architectural pieces by Saenredam, Berckheyde,

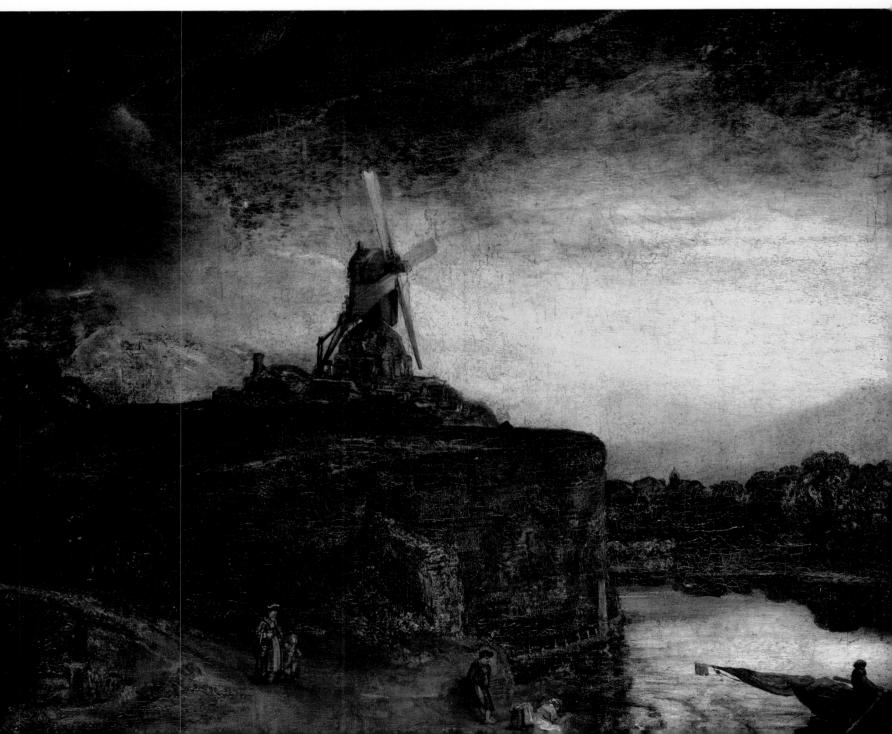

Ruisdael (1628/9-82): Cornfields, $100 \times 130 cm$

Summer affords endless inspiration. Bruegel, for example, experimented in a complex, Mannerist way with a curving composition which included harvesters relaxing beside their crops. His rustic bumpkins, however, would have been out of place in Poussin's Summer, a classical composition of restrained dignity. Cutting his corn parallel to the picture frame, he aligned it with a blessing arm - the key to his concept of harvest. Poussin's monumental harvest scene was constructed round a biblical scene of giving and receiving. Ruisdael, on the other hand, differs from both these artists. He did not want to idealize nature, and, ignoring anecdotal and moralizing material, painted what he saw. His technical skill, reflected in his fluid brushwork, was employed to describe space naturally and light spontaneously. This is a plain field under an everyday sky. The glorious sweep of warm yellow dominating the smokey-greys and rich browns is a tribute to the real world, not to the artist's powers of invention. Ruisdael can be distinguished here for his cool observation and detached appreciation - passive qualities, perhaps, but ones with their own quiet merit. One has to think of that over-popular Cornfield by Van Gogh where a crop the colour of burnt toast writhes beneath a heavy sky, blue-black like bad bruising and filled with ominous birds. Why, one wonders, should a violent painting like this, humming with subjective tensions, be preferred to a calm dispassionate image such as Ruisdael's.

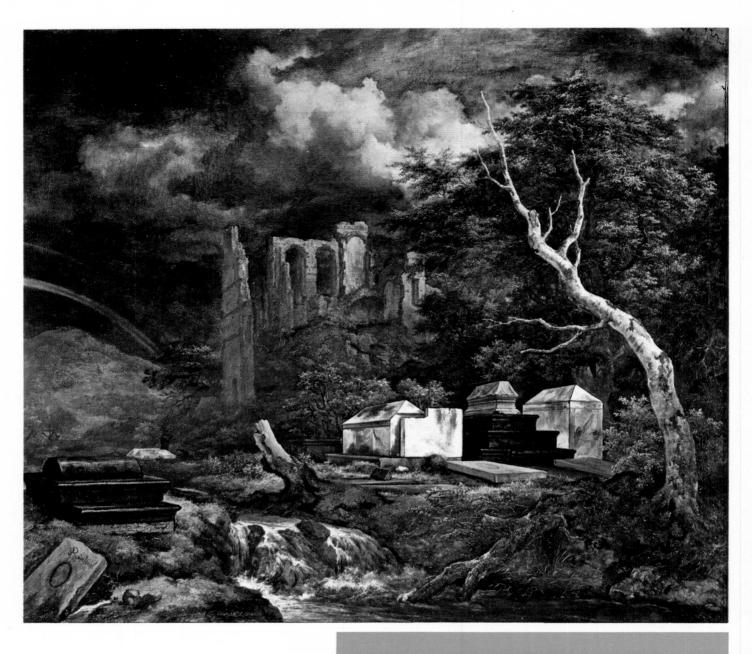

Koninck: Landscape. 93×112 cm

Ruisdael (1628/9-82): The Jewish Cemetery, $84 \times 95 cm$

Here we have all the material for a horror film. The blasted tree, darkened sky, and title itself all conjure up images of ghouls and gremlins. This is a surprising painting if one comes to it fresh from the daylight honesty usually associated with the fat clouds and sunny scenes of the Dutch Realists. It provides salutory warning.

Just as a sobre man may, on occasion, get roaring drunk, a generous man reveal a twinge of meanness, or an acknowledged bore recount a devastating witticism, so any painter may be expected to act out of turn, and produce the unexpected.

How, in this case, has Ruisdael achieved such a ghoulish and supernatural effect? The answer is, again, disconcerting for, on close examination, we see that the individual components making up this work are all plausible. Blasted trees, for example, can be discovered on any lane. This painter creates a nightmarish scene by straining the bounds of common sense, without breaking them, and by displaying a theatrical flair for composition and lighting.

If you compare this painting with El Greco's *View of Toledo* you will sense a difference in approach. Ruisdael plays the part of a narrator explaining the real world, even though he selects startling events and puts on a horrific accent. El Greco, on the other hand, does not simply edit and colour everyday material but uses it as the starting point for a more imaginative exercise. Thus while Ruisdael gives a mannered account of reality, El Greco verges on expressionism. Art, with the former, is a question of interpretation, but with the latter a source of alchemy.

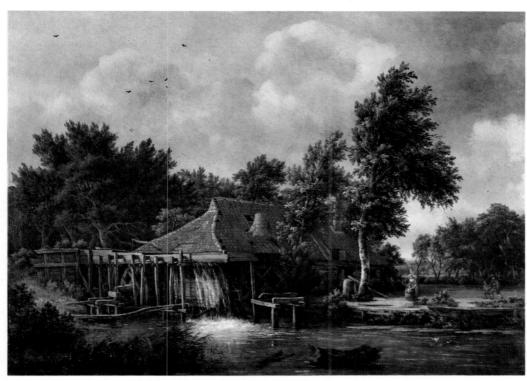

Hobbema: *The Watermill*, $62 \times 85 \cdot 5$ cm

Hobbema: The Road to Middelharnis, 104×141 cm

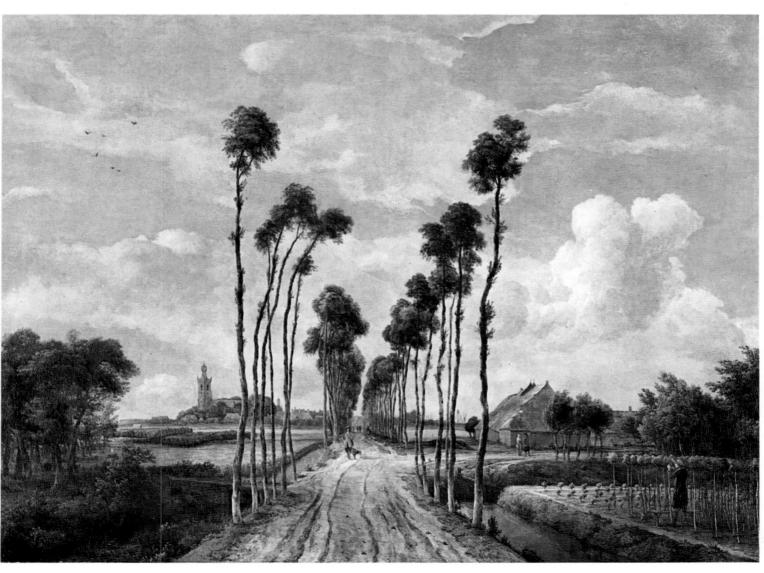

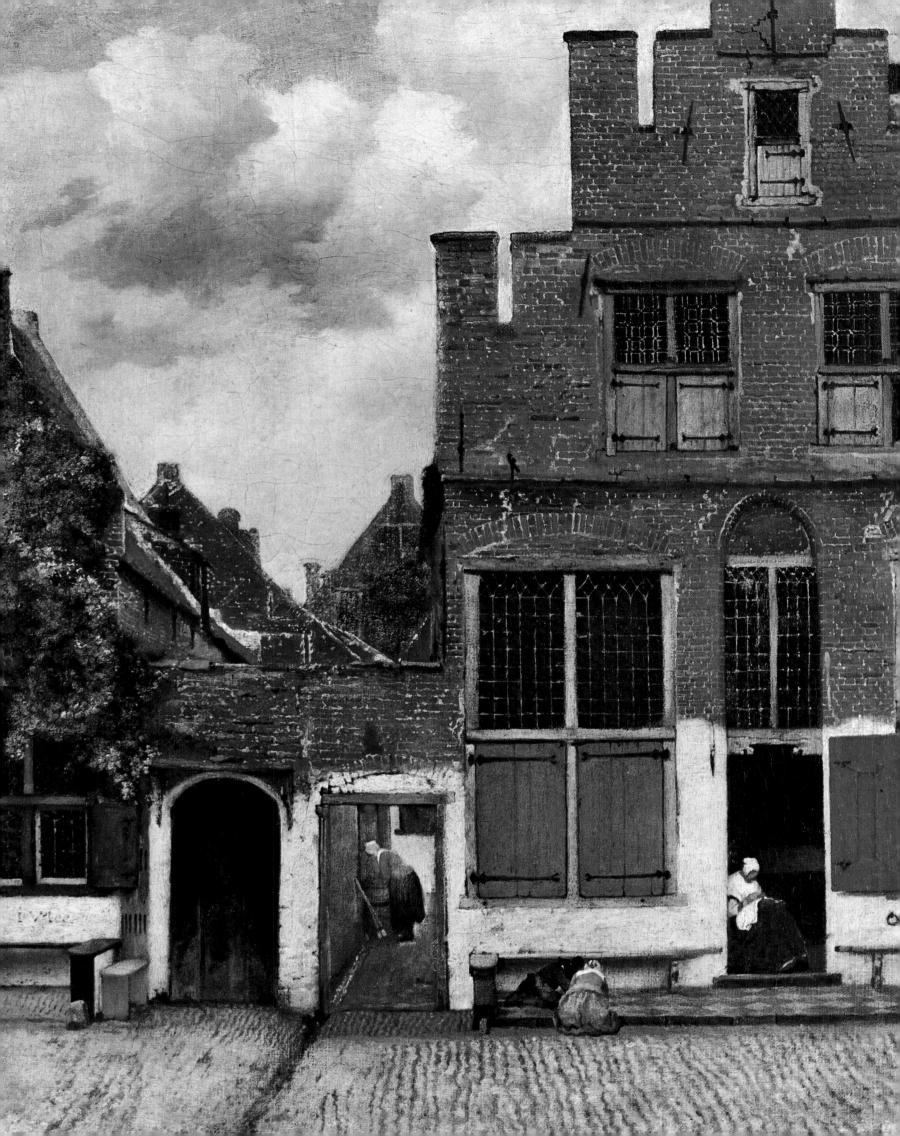

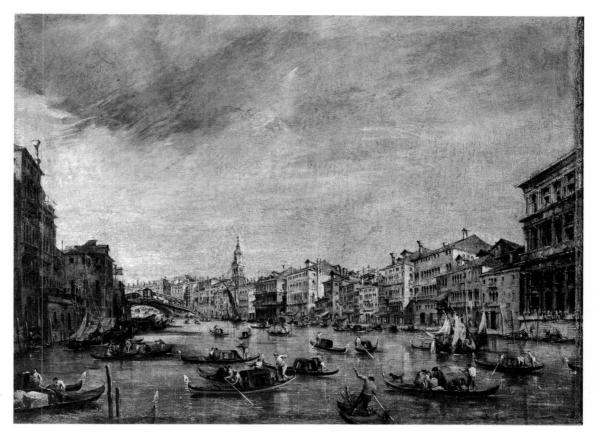

Guardi: View of the Grand Canal, 56 × 75cm

and De Witte. Detail, in these works, benefits from being part of a tight geometrical framework. As far as even focus and atmospheric unity go, the masterpiece in this category is Jan Vermeer's *View of Delft*, a painting whose calculated planning is combined with an incredible subtlety of tone.

Eighteenth-century landscape: a dull period

With individual exceptions, landscape painting went into a decline in the eighteenth century – rather as it had after the Renaissance. The impetus behind the experimentation of the Dutch school paled; nature was no longer treated with such respect. Scientists, such as Newton, who explained the universe in terms of clockwork, took the magic out of life, and made nature seem boring. In this age of reason there were topographical recorders of genuine scenes and landscape painters, often artists, such as Salvator Rosa, who chose this subject as a fervid form of escapism. They glided along on established formulas, making pictures to pattern. Occasionally they might be jolted into a genuine reaction by a novelty, as when Canaletto, manufacturer extraordinary of Venetian scenes, accidentally stumbled on a stonemaker's yard, which he recorded with authentic delight. However his slick competitor, Guardi, never broke out of his Rococco cocoon, remaining a hostage to his own brilliant artifice.

Canaletto: Perspective. 131×93 cm

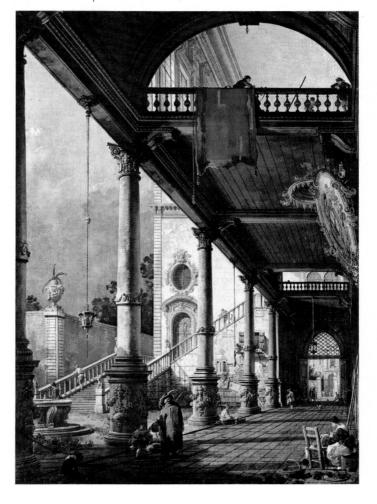

Opposite Vermeer: The Little Street in Delft, $54 \cdot 3 \times 44$ cm

Watteau: delicate delusions

The most touching of these airy, eighteenth-century illusionists is Watteau. Like Claude, he was addicted to a golden world tinged with nostalgia, but where Claude had worked on a monumental scale, Watteau was much more intimate. The delicate grace of his silk-clad figures and leafy trees suggest the finest set-painting: such details could hardly be refined any further without splintering. It is no coincidence that his parks should be the formal playgrounds of the *ancien régime*.

Watteau's wistful debt to the classical tradition was a philosophic one: he tried to paint perfection, conjuring up established ideals. In this he was in tune with eighteenth-century thinking; Gainsborough, for example, told a patron that he had never seen any 'place' which offered a subject equal to the poorest imitation of Claude.

Landscape gardens

Ironically, Gainsborough belonged to a period in which his fellow countrymen were at pains to make actual 'places' into living versions of classical paintings. Altering physical sites, by moving lakes, hills, villages, statues and bridges, they

Velazquez (1599–1660): View of the Garden of the Villa Medici, Rome, 48×42cm

This is an understated masterpiece. Colours, lines, and shapes unite to form a satisfying whole, in which separate parts retain their individuality. Like many of the background details in paintings by Bellini or by Giorgione, it contains both balance and variety, a difficult aesthetic achievement. See, for example, how Velazquez has arranged the similar, and yet quite individual, shapes of dark trees in contrast with a plain, horizontal wall. There is a deceptive simplicity at work. The formality of this composition creates a stillness which gains dignity from a restrained, but harmonious palette. Velazquez's mastery of sombre tones (anticipating Goya) is reinforced by subtle brush work. Without the mirror-polish of the Middle Ages, or the putty work of the twentieth century, his strokes reveal a fluent dexterity. He can make a point about a surface both in terms of colour and texture, varying the density of his pigment to suit the surface he describes.

Velvet Bruegel, working on an outdoor theme, would have been temperamentally unable to resist a cornucopia of flowers, fountains, statues, leafy vistas and a Noah's ark of assorted wild life. Velazquez, however, remains austere and omits fanciful details. Ignoring the splendours of Rome, he focuses on an empty garden. This not only suggests a certain modesty, but provides a puzzle. What might Velazquez have achieved had he turned more of his attention to landscape painting? Velazquez is best known for his role as a Spanish royal portraitist, just as the Frenchman, David, is best known, at a later date, for his role in revolutionary politics. But Velazquez's quiet garden, like the equally balanced view David produced from his prison window, provides food for thought - suggesting private reactions behind public commitments.

Watteau (1684–1721): Embarkation for Cythera 128×193cm

This is the painting which won Watteau the privilege of belonging to the French Academy. The Academicians recognized his talent, but were at a loss as to how they could describe it, so they created a new category, classifying him as a painter of *fétes galantes*.

Hard to translate precisely, this title nevertheless savours of aristocratic diversions, of poignant encounters shaped by courtesy and tact. We are a long way, here, from Bruegel's practical landscapes, in which each season enforces its own rules for survival, whether of ploughing, sowing, harvesting or simply keeping warm. Bruegel includes obvious references to food and fuel, and it is in character that when he paints Icarus's mythical death he contrasts it with a scene of careful cultivation. And, just as the furrows of his field record a realistic interest in farming, so the bulging forms of Bruegel's dancing peasants (like those in Ruben's later *Kermesse*) transmit a primitive urge to reproduce.

Not so Watteau's image. Sex has become love, and the landscape altered accordingly from one of boisterous facts to one of fragile feelings. Direct painting has given way to aetherical suggestion. This is a delicate, misty setting in which couples are clasped in an elegant chain. Graceful lovers - affectionately linked beneath a bust of Venus, rising, parting, casting a wistful glance behind them, descending the bank move wistfully away from their enchanted shrine. Romantic passion, with all its magnetism, is transitory and hardly suited to the everyday world. Watteau's message is a psychological one relying on the subtlety of his technique to ensure the subtlety of his theme. Evaporating love is caught in melting paint work. A bad reproduction, loosing the pastel lights of soft silk, pale pinks and pearly greys would obliterate the finesse of this painting, in which a one-time set painter creates a theatrical tableau of some distinction. It is, however, amusing to recall Poussin's classical constructions at this point. If his outdoor scenes, and mythical masterpieces had all the deliberation of the town planner, surely Watteau's flirtatious Venus, garlanded in roses, and jewelled cockle of a boat are evoked in a lighter vein - say that of an interior decorator?

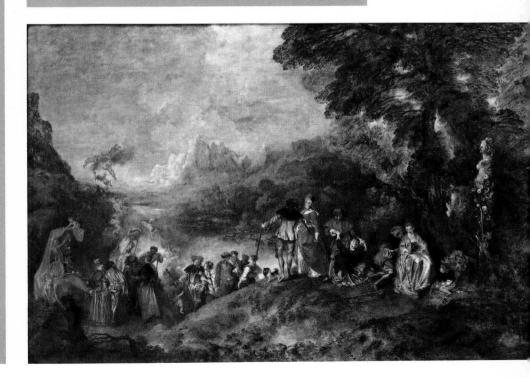

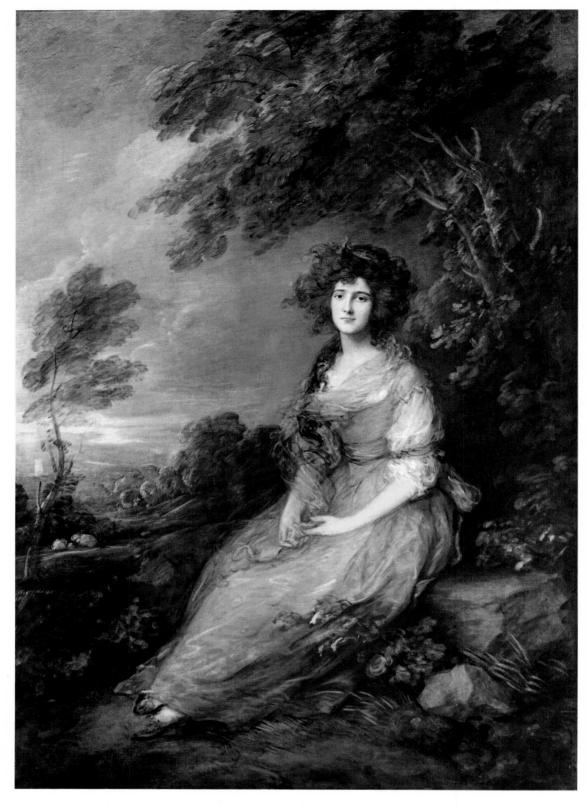

Gainsborough: Mrs Richard Brinsley Sheridan, 220×154cm

tried to evoke the ordered beauties of classical landscape painting. The landscape garden at Stow, where vistas were arranged in sequence, was a case in point. When these formal gardens and also picturesque ones, were then used as the starting point of landscape paintings, history had gone full cycle.

Turner and the elements

Turner typifies the best of the English landscape school in that he was brought up on classical patterns, which he mastered, but then evolved his own completely personal style — a style which can only be called Romantic. Baudelaire said that Romanticism is not so much a question of subject as

of feeling. Turner's work personifies this. He has the old Northern desire to express mood and emotion in pictorial terms, refining it as never before. Turner's finest paintings are transparencies: like the rainbow effects of an oil film on a wet road, they give an ethereal effect. It was no coincidence that Turner was a master of water colour painting. His contribution to the landscape tradition lies in taking the earth out of the earthly paradise. Just as Chinese Zen painters concentrated on evoking the eternal qualities of 'mountain' and 'water', so Turner, with an inclusiveness like that in Shelley's 'Ode to the West Wind', dealt in 'essences'. Painting Norham Castle, for example, Turner creates a translucent atmospheric harmony which still seems a reflection of the real world.

Turner was never more at his ease than with the impossible. His clouds merge air, wind, light and water, making a poignant mystery of where sea touches sky. Significantly, the southern site which inspired him most was Venice, a city built on water.

Turner's dramatic vision of man doomed in the face of

nature's destruction is negative, as his poems and titles show. but the level of his aesthetic expression allowed him to rise above his own personal pessimism. The combined brilliance and subtlety of his palette, whether clear or misty, lifts his fatal fires and sunsets into the impersonal realm of pure tragedy. Colour. with Turner. is cathartic.

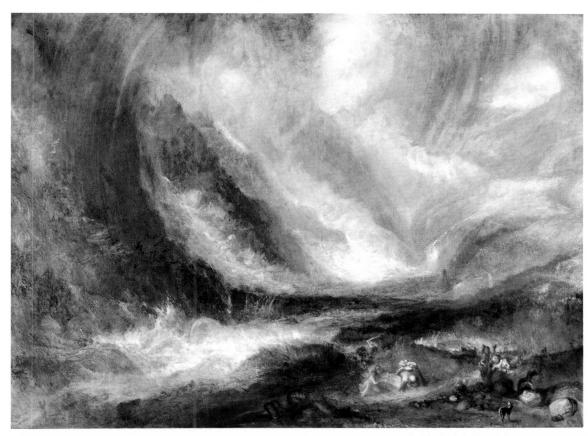

Turner: Snowstorm, Avalanche, and Inundation, 91·5 × 122·5cm

Turner: *Caernarvon Castle*, 96×140 cm

Turner: Windsor Castle seen from Salt Hill, 25 × 73cm

Constable: canals not oceans

Where Turner painted the *Fighting Temeraire*, Constable painted a hay cart crossing a stream. Where Turner was operatic, Constable was domestic. The rotting planks and old willows of his boyhood home inspired him for life, just as Wordsworth, reintroducing pantheism with moral fervour, revealed wisdom in simple, rustic episodes. Constable praised ordinary things. He stated, quite categorically, that he had never seen an ugly thing in his life — a statement threatening the perfecting mind of the classical tradition.

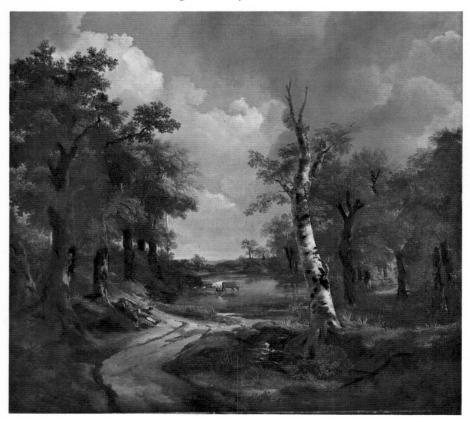

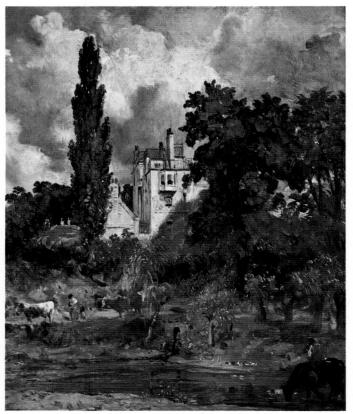

Constable: The Admiral's House, Hampstead, 35 × 28cm

The paradox of the classical naturalist

Constable was a naturalist, owing much of his direct sight to the Dutch. In choosing the sky as his 'chief organ of sentiment', Constable paid clear homage to Ruysdael. And yet his naturalism cannot be taken for granted. He worked from nature and then used his preliminary sketches and drawings to complete finished works corresponding to a specific theme in his own mind. His deep knowledge of earlier classical painting contributed to his underlying ability to compose

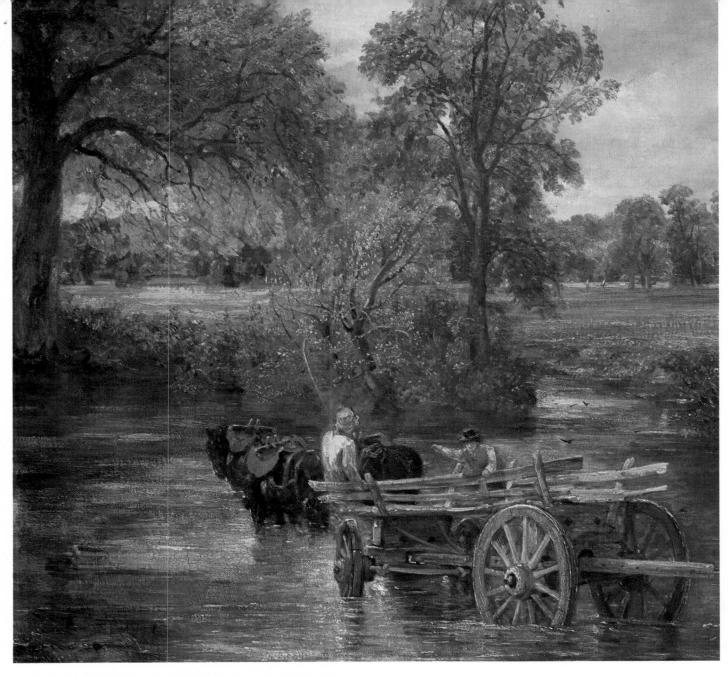

Constable (1776-1837): The Haywain (detail)

Constable is famous, his works known throughout the world: his paintings are reproduced in reputable art books, as well as on cards, calendars and biscuit tins. There is, therefore, no need to explain a Constable because it is already common knowledge, common currency. This popularization is relatively recent, and it is significant when we study landscape - or any other branch of painting - to reflect that an image which we take for granted might, when first displayed, have had far greater rarity value. Thus Constable, allowed to see a famous Claude Lorraine in a private collection, studied the work and, for the rest of his life, counted himself very fortunate to have seen it. Similarly, when The Haywain was exhibited at the Paris Salon in 1824, it made a tremendous impact: it was a unique chance for artists and public alike to see Constable's work. Contemporary 'knowledge' of this artist's work brings home our debt to photography, and photographic reproduction. For although a photograph may take a work out of context (placing an altar piece on a coffee table or obliterate a sense of patina, it can nevertheless make a rare work available to a limitless number. Like the seven loaves and seven fishes, multiplied to feed a host, Constable's works multiply on demand.

Constable: Salisbury Cathedral from the Bishop's Garden, 89×114 cm

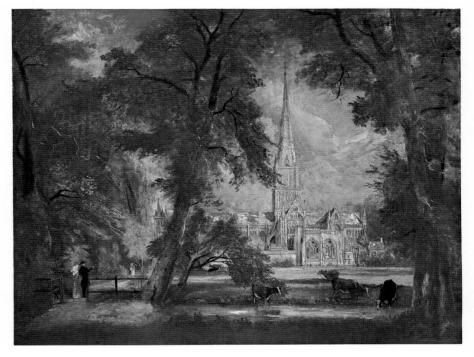

Landscape Painting: Girtin · Wootton · Siberechts · Cozens · Wilson

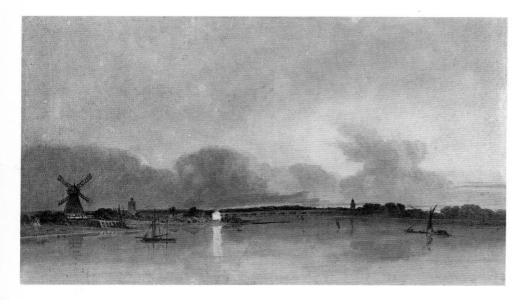

LEFT **Girtin:** The White House, Chelsea, $30 \times 52 \text{cm}$ Centre. Left **Wootton:** The Beaufort Hunt, $203 \times 244 \text{cm}$ Centre. Right **Cozens:** The Lake of Albano and Castel Gandolfo, $48 \times 66 \text{cm}$

Below, left Siberechts: Landscape with a Rainbow, $81 \times 102 cm$ Below, right Wilson: Llyn-Y-Cau, Cader Idris, $48 \times 71 cm$

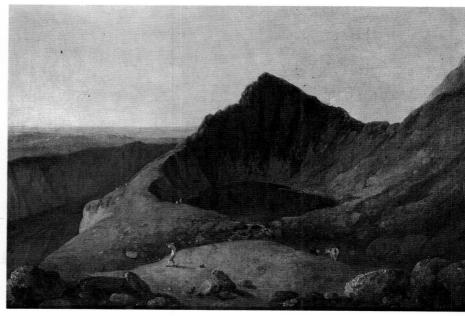

his subject matter. Although his sense of structure is played down, it has given his paintings an underlying seriousness which has enabled them to stand the test of time. Constable's fortune lay in acknowledging the poetic tradition as well as observing for himself.

The French connection

Constable's *Hay Wain* was exhibited in Paris. It had a profound effect on contemporary French painters. His influence is felt, for example, in the carefully studied oaks of Theodore Rousseau of the Barbizon School. One person who remained immune to Constable and his 'chiaroscuro of nature', however, was Corot, a subtle, tonal colourist who managed to simplify his motifs through natural discretion and the habit of painting motifs in the far distance. In France, in the Morvan Mountains, he achieved his own compromise between classical elegance and natural observation. These perfect paintings are shown up by later, feathery works in which nymphs and willows predominate. Where Constable (after his wife's death) or Van Gogh (going steadily mad) produced black, tortured vistas, Corot went the other way and relaxed into sentimentality.

The new democracy: Courbet and realism

If the shimmering light of Corot's later paintings seems over slight. Courbet's canvases reflect a different style. At times brash or banal, he employed crude colour and 'realistic' forms easily appreciated and easily exhausted. His policy, which he expressed with all the force of his strong personality, was to advocate realistic art as the art of the people. Whereas in the Middle Ages religion had influenced landscape, in the nineteenth century it was more flavoured by politics. Classicism was the language of the elitists, realism of the boors. Thus extremists were equally enraged by the 'artificial' refinement of academic classicism or the 'vulgar' brio of the realists.

Courbet was direct. In painting landscapes as he saw them, rather than as he thought he should see them, he anticipated much of the spontaneity of the Impressionists. As a group they represented the virtues and the vices of spontaneity. They often painted out of doors and they often worked straight from their motif, without going through the laborious preparatory stages characterizing the early landscapists. They would paint for pure enjoyment, not to prove anything. Where Elsheimer used the biblical theme of the Flight into Egypt as an excuse to paint a landscape, Monet painted poppies from pleasure: the brilliance of these poppies, a simple hedonistic image of scarlet on green, captures the essence of summer. Later, however, Monet. Sisley and Pissarro lost their original freshness, and Monet frequently pushed Impressionist measures into absurdity: his late Cathedrals are so many melting ice-creams, where his once fluent brush work has degenerated into sloppiness.

Colour rules

When the Impressionists were at their best they wove a pattern of light and shade over their canvases, eliminating hard outlines and graded shading. They saw the purple in

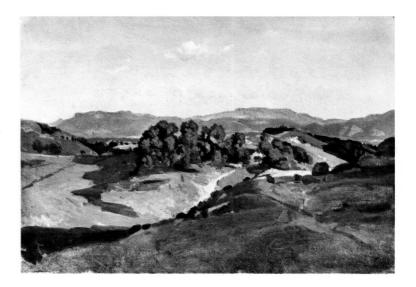

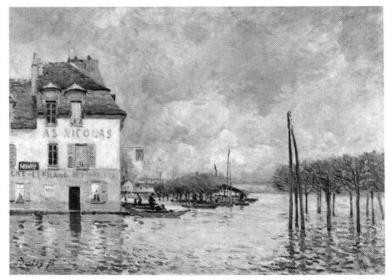

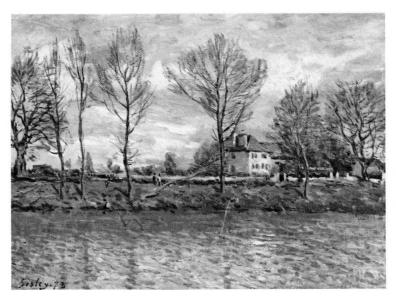

TOP Corot: The Winding Road. 34×47 cm

CENTRE Sisley: The Flood at Port-Marly. 60×81 cm

BOTTOM Sisley: The Island of the Grande latte. 51×65 cm

Renoir: *The Path through the Tall Grass*, $60 \times 74 \text{cm}$ **Renoir:** *The Path through the Tall Grass*. (detail)

Renoir (1841-1919): La Grenouillère, 66×79cm

The village which gave this canvas its name is of interest within the overall development of landscape painting, for it was here that Renoir and Pissarro developed the bright palette and spontaneous brushwork which we associate with the Impressionists. To the spectator knowing this, and finding himself in this bit of countryside, it would be hard not to view the scenery with Impressionist eyes, to gaze at light falling through foliage with Renoir-tinted-glasses. Take this link between place and personality a stage further and you may well discover that you see whole categories of natural effects through the eyes of the painters who have processed them. It is intriguing to gauge the extent to which we unconsciously reflect their vision. It is possible, for example, to 'see' the Alps in terms of romantic, 'picturesque' images, suggested by Turners of dramatic scale and sublimity, but - at the same time - to envisage the Riviera in more colourful, and casually concocted sequences, suggested by much later artists.

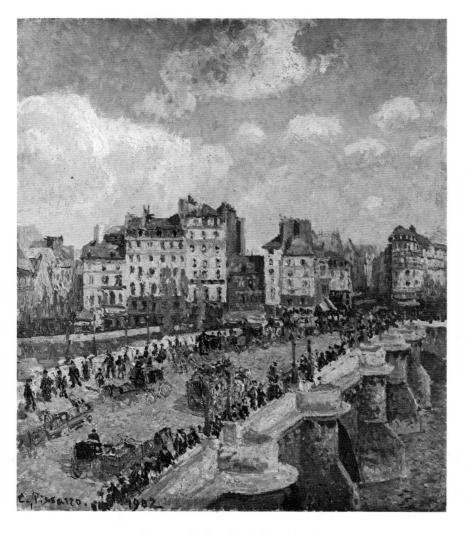

BELOW Courbet: The Lake at Neuchatel, 96 × 123cm

RIGHT, ABOVE **Pissarro:**Woman in an Orchard, 55 × 65cm

RIGHT, CENTRE Pissarro: Orchard in Pontoise, Quai de Pothuis.

 65.5×81 cm

RIGHT, BELOW Pissarro: Entrance to the Village of Voisins, $46\times56cm$

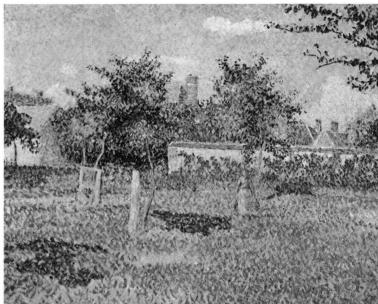

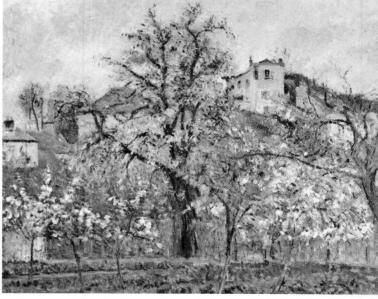

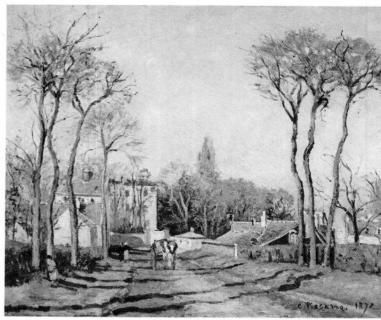

Monet: Wild Poppies, 50×65 cm

shadows and, as a quick flick through this book will show, used pure colour to an extent which would have amazed their predecessors. Black and brown were exterminated, for colour absorbed the Impressionists as architecture had obsessed the classicists.

Just as Constable had brightened his work with white flicks from a palette knife. Pre-Raphaelite painters had brightened their range of colours by working on a wet white ground, not a tinted one, so Monet, working with Renoir in the early 1870s, profited from the latter's addiction to pure colour — a natural instinct in an ex-painter of china.

Not only was there a new emphasis on colour in the sense of brighter pigmentation, but also a new preoccupation with colour symbolism. Turner and Delacroix, for example, were both intrigued by Goethe's abstract colour theories, while Seurat's devotion to colour bordered on scientific fanaticism.

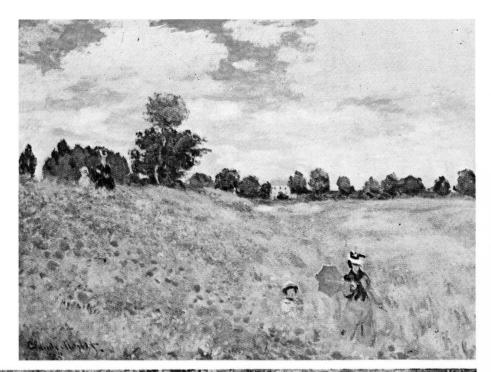

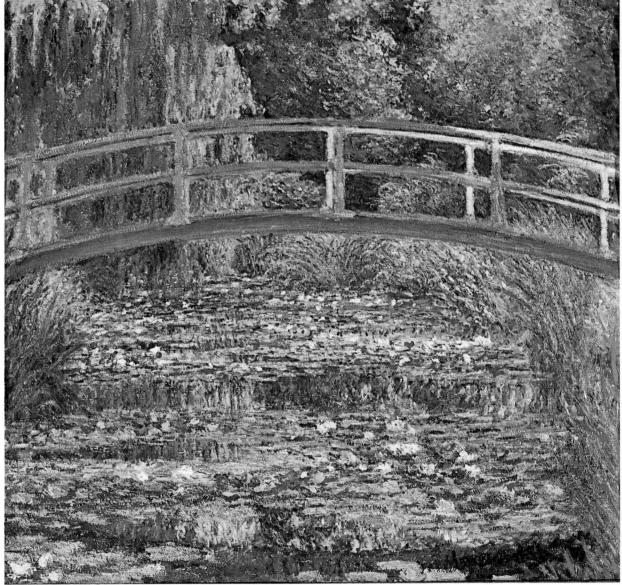

Monet: The Bridge with Waterlilies, $89 \times 92cm$

OVERLEAF **Seurat**: La Grande Jatte, 205.7×305.8 cm

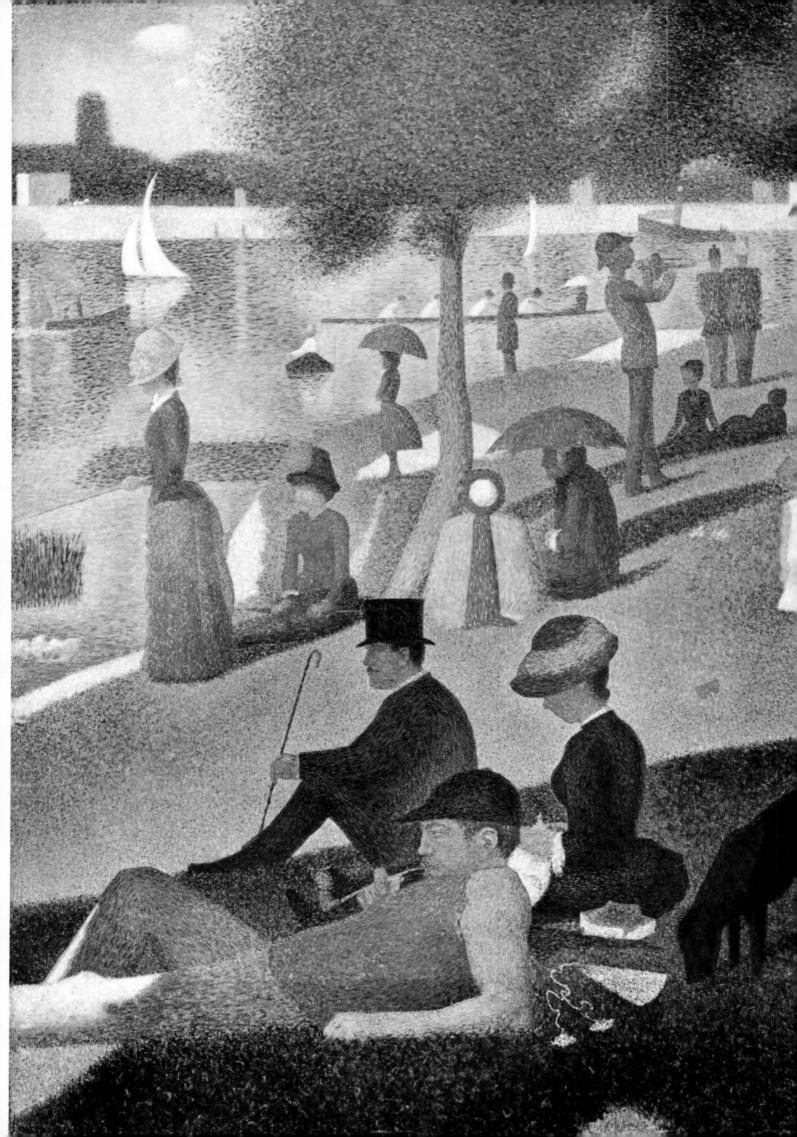

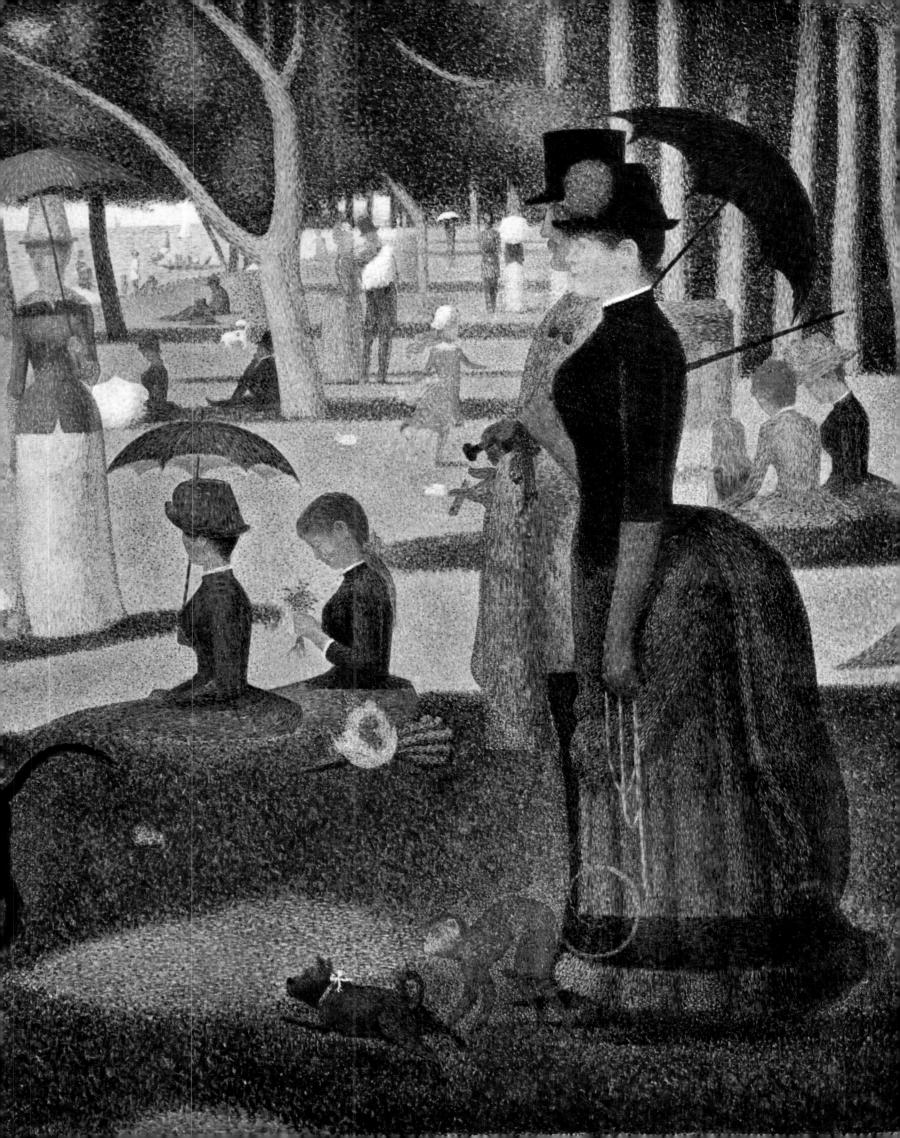

Seurat: The Banks of the Seine, 65 × 82cm

He made a rigorous study of modelling in colour, creating landscapes whose still form is superficially enlivened by a surface of tiny multi-coloured dots, as minute as the granite flecks on the smooth contours of an Egyptian statue.

Cézanne: making his own building blocks

Where Seurat reduced his brush strokes to pin-points, working with so many hundreds and thousands. Cézanne built with larger chunks of clear colour, which he arranged in

multi-faceted planes, like the images seen through a kaleidescope. His objects were fractured into a series of representative planes. This allowed him to achieve a sure sense of three dimensions, while at the same time working with geometric units which allowed him to make abstract patterns on the flat surface of the canvas. Often running his constructional girders parallel to the picture frame, as Poussin had, he was nevertheless quite unlike Poussin in that he learned to compose from nature rather than with nature: 'Je deviens . . . plus lucide devant la nature'. This lucidity, this awareness of what natural scenes actually looked like, led him to break or bend hard lines (even if infinitesimally) so that the eye could concentrate on mass and volume rather than marching round a series of unnatural outlines. In this he was again unlike Poussin, but perhaps his greatest debt to this great classicist was one of seriousness. Cézanne was dedicated to duty. His landscapes reek of toil. There is a sense in his best work that nothing is out of place, that every colour and every angle contributes to an all-over plan; accurately chosen to support and accentuate its neighbours. Glance, for contrast, at a selection of Impressionist paintings. Their loose, luminous splashes of light are more like shorthand notes, notes which could be altered. Similarly, their cheap cafés, girl-friends in rowing boats, and picnics by the river suggest an adaptable joie de vivre. Even when they were virtually starving, the Impressionists caught a relaxed, nonchalant mood; their landscapes convey an ever-popular sense of holiday.

Seurat: Bathing at Asnière, 201 × 302cm

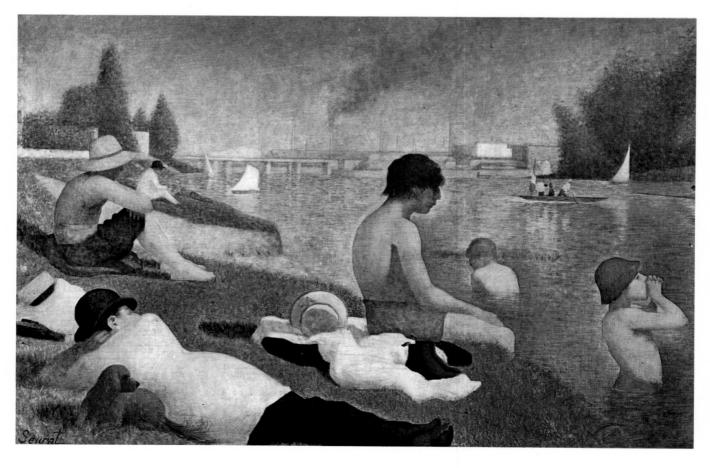

Cézanne: The Rocky Landscape at Aix, 65×81 cm

BELOW, LEFT **Cézanne**: The Landscape at L'Estaque, 73 × 91cm

BELOW, RIGHT **Cézanne**: The House of the Hanged Man, $55 \times 66cm$

Capturing a mountain

The adolescent turmoil which inspired Cézanne's early works was slowly sublimated: paring down what he saw, he learnt to present images of suave decision. And it is in this hardwon objectivity, where passion is not lost but held in check, that Cézanne triumphs. His trees and rocks are plotted with the same certainty with which he painted apples, pears and plates; his landscapes may be seen as 'natural' still-lifes. His cool confidence in placing and defining Mont Sainte-Victoire, for example, shows just how far the European tradition had evolved. After shying away from mountains,

or producing childish equivalents, European artists, such as Mantegna, had repeatedly returned to this theme which Cézanne, in his accumulated maturity, captured with ease.

Modern painting: change becomes the norm

In considering the gradual development of landscape painting, the viewer becomes increasingly aware of strong links between groups and individuals. As in a study of genealogy, dominant traits may skip a generation but often reappear in subsequent branches of a family tree. Thus the British landscape school's debt to their Dutch predecessors was ex-

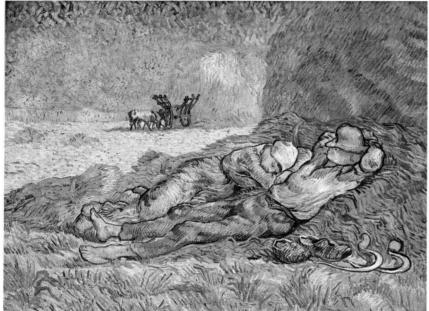

Van Gogh (1853–90): Meadow with Butterflies (detail)

Van Gogh was an Expressionist. A Northerner, he painted with emotion and, after absorbing the brilliant natural colour of Provence, produced works of psychic as well as coloristic intensity. His plants, when compared with the filigree designs in an old Paradise garden, writhe with life, like fish in a net. Similarly, his suns do not simply flow in his skies, but pull them into action; tense waves of linear dashes flow all over his paintings like so many electric currents, each object having its own magnetic aura.

ABOVE Van Gogh: Thatched Roofs at Montcel,

Van Gogh: The Rest. 73×91 cm

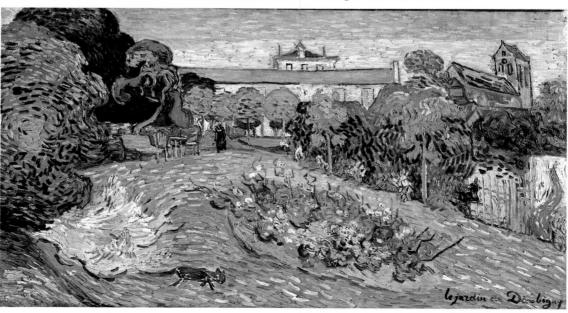

Van Gogh: The Garden of Daubigny, 55 × 100cm

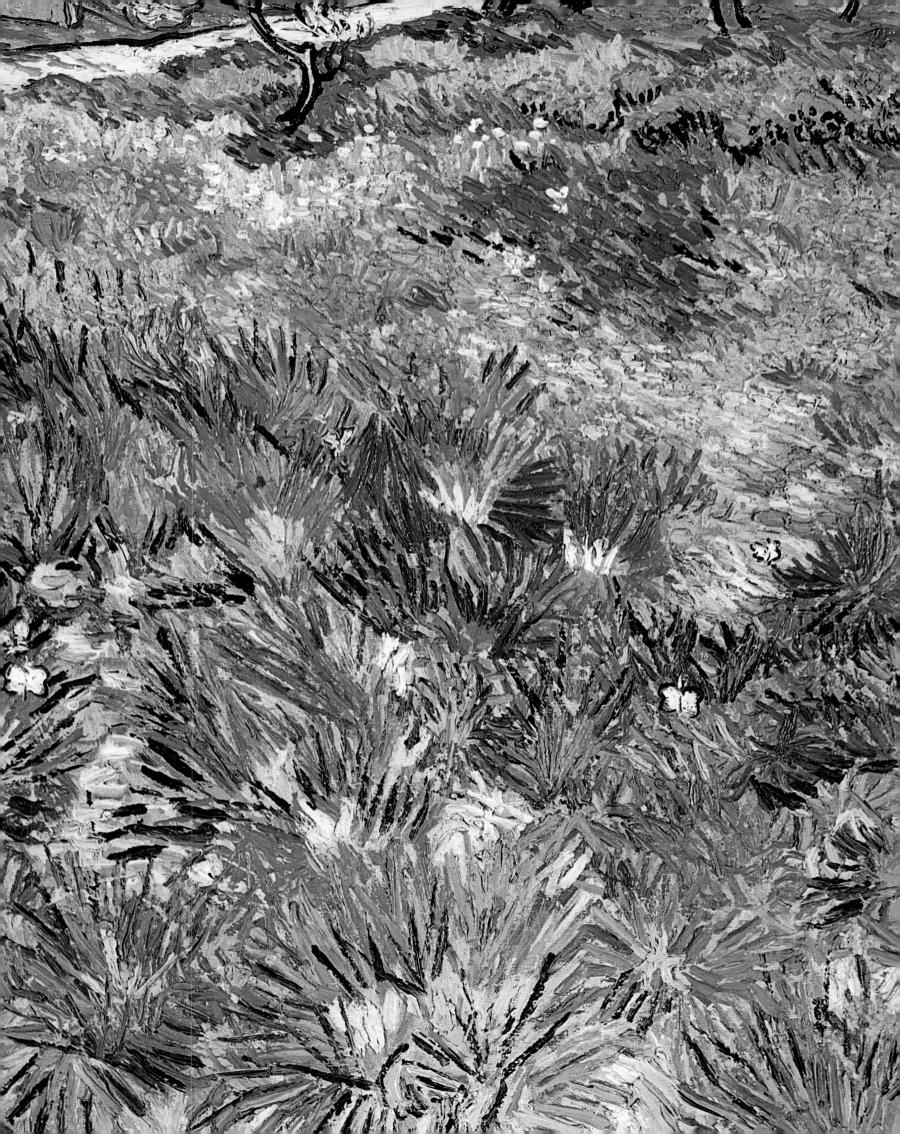

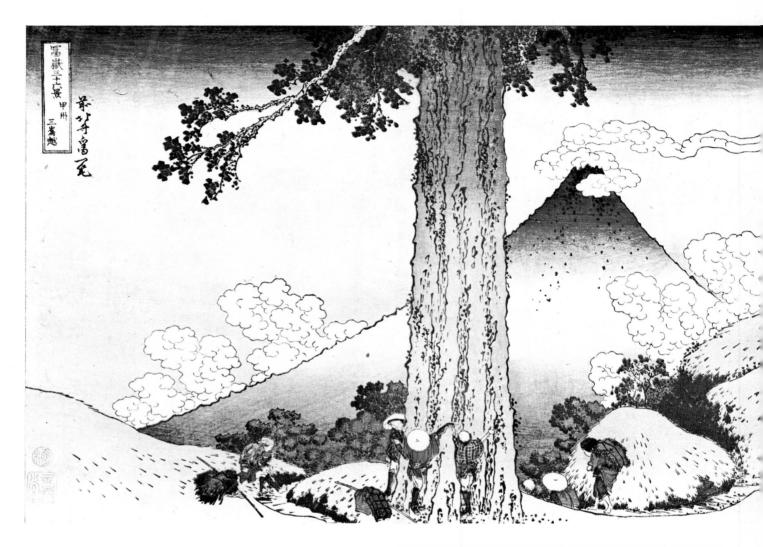

pressed in an exhibition entitled 'The Shock of Recognition'. The shock, with modern art, is one of pure surprise.

The country scenes and rustic dwellings which reappeared, virtually unchanged in centuries of European painting, are being steadily bypassed by urbanizing and industrial programmes literally altering the face of Europe. Mentally add a pylon, or a tower block, to a painting by

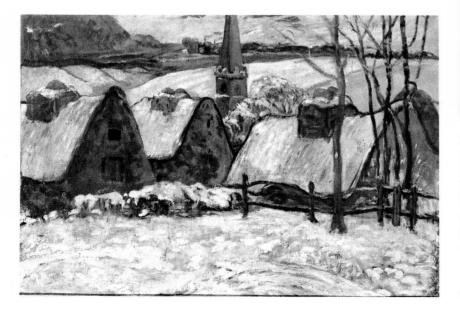

Katsushika Hokusai (1760-1849): Fuji, 26×35cm

Line defines form, and colour suggests shape. Hokusai contrasts bold and delicate colouring within the framework of his design, a design of calligraphic brilliance. This is the kind of design which, arriving by accident in a tea chest, could throw a European painter into confusion: Manet, Degas, Gauguin and a host of others included painted references to Japanese prints in their portraits and still-lifes, and paid tribute to Japanese aesthetics in ingenious constructions in which they tried to capture contemporary life. Casual everyday scenes, of the kind Baudelaire praised in his essay on the painter of modern life, came easily to Hokusai, a draughtsman with the ability to pare a fleeting moment into an eternal pattern.

Bruegel or Bellini and you will sense how agrarian Europe has altered. In addition, improved transport has given artists aerial vision, but has helped to erode the old boundaries in Europe, which is now united as a Common Market. Whereas, in the distant past, the contrasts between the north and the south sparked off a whole series of cultural hybrids, more recent paintings have absorbed new material from a much wider field. Imported Japanese prints and African carvings,

Gauguin: Breton Village under Snow, 62 × 87cm

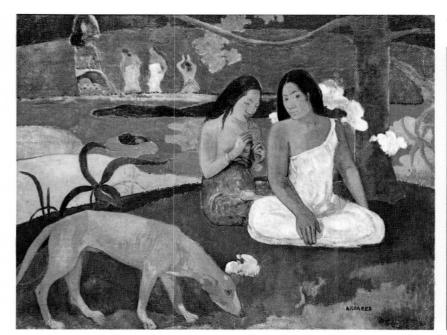

Gauguin: Arearea, 75×93 cm

'Le Douanier' Rousseau (1844–1910): Virgin Forest at Sunset (Negro attacked by a Leopard), 108×171·5cm

Rousseau told Picasso that he, Rousseau, painted in the 'Egyptian' style. Who is to say? He may well have been right for the crisp, neat way in which his patterns are composed does reflect some of the deliberation of the ancient Egyptians. His paintings appeal to children and sophisticates alike, and this reflects the serious care which has gone into their fabrication. It is this kind of directness, which makes a genuine primitive preferable to a whole host of second rate Constables or pseudo-Cézannes, however stylish their tricks. Anyone who has visited a provincial exhibition will remember how these works stick in the imagination: they are unique, sincere, and a law unto themselves.

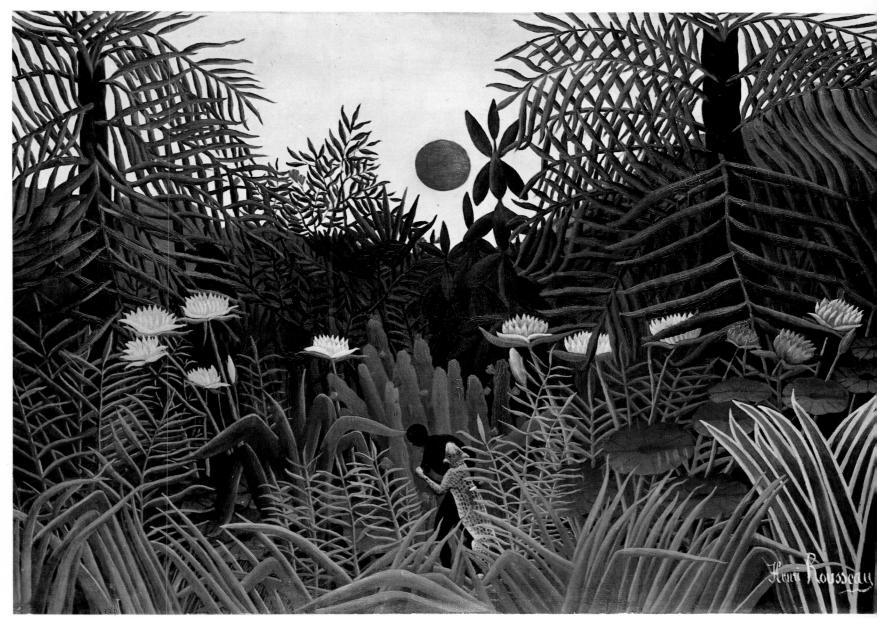

MAHANA no Ateca -

Gauguin (1848-1903): The Day of God (Mahana no Atua), 69·6×89·9cm

The myth of the earthly paradise has always had exotic overtones. Echoes of the oasis dwelling described in the Bible, or of the Persian paintings brought home by early Crusaders, have added spice to Northern dreams.

Gauguin, a Frenchman married to a Dane, left Europe to paint in the South Seas. Inspired by the vibrant colour, lush vegetation, and glowing lights of these islands, he painted their inhabitants with growing respect. With Gauguin, the myth of the romantic savage found a new devotee, one who could praise the gentle generosity of islanders at the expense of his own, threadbare civilization. There is a monumental quality about his tropical Eves and Marys who inhabit their gaudy, parrot coloured landscapes with the quiet assurance of Renaissance beauties at home in the fields of Florence or Padua.

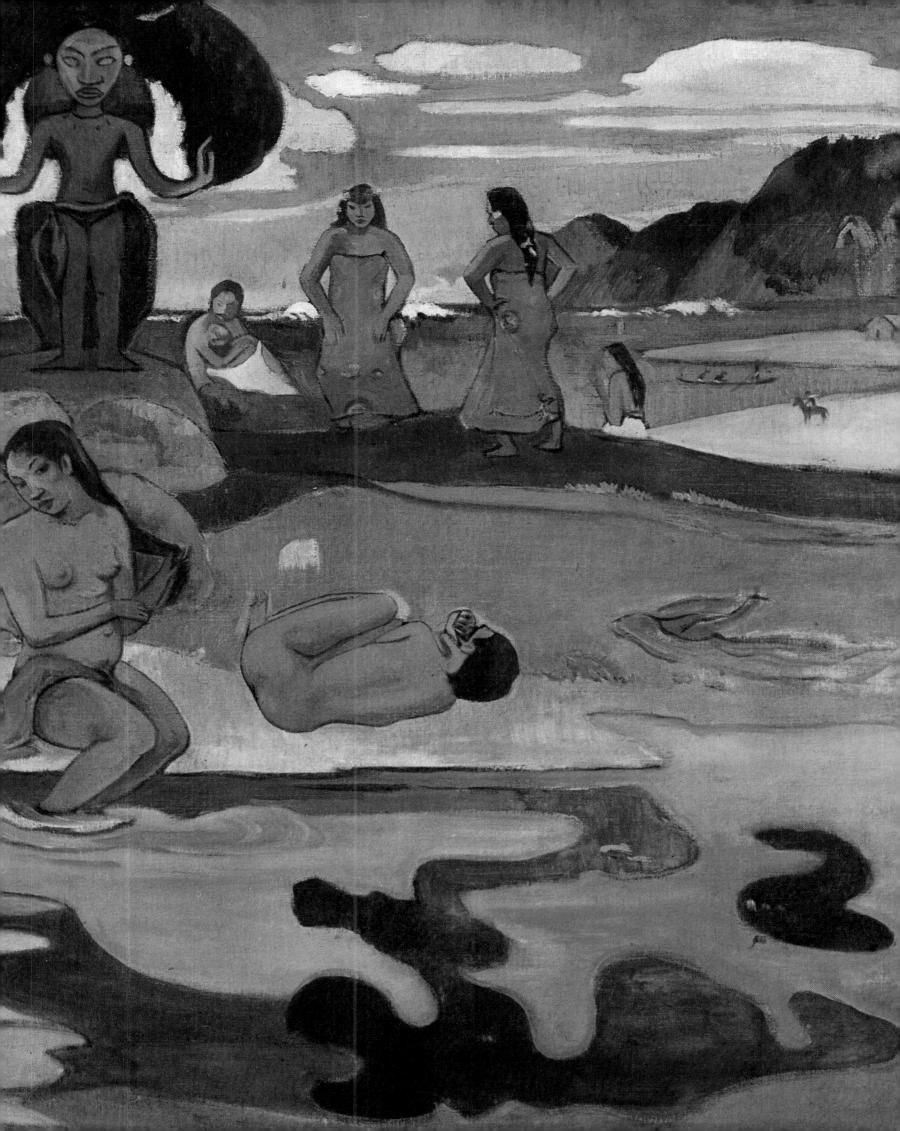

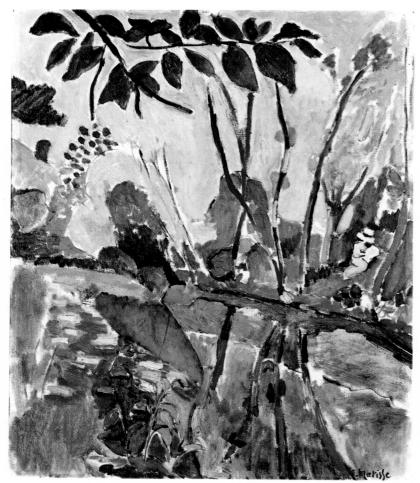

Matisse: The Riverbank, 73×61 cm

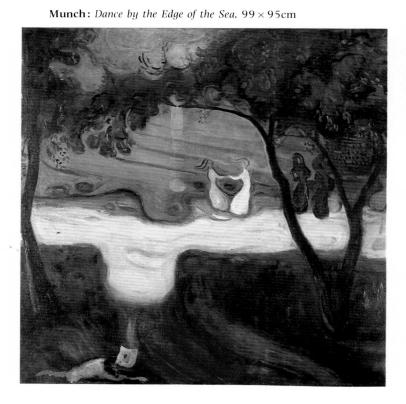

Matisse (1869-1954): The Blue Window, 131×90cm

This composition depends on blunt areas of colour and a strong sense of line. The result is vivid, and highly decorative. Whereas early landscapists might include a window in a religious scene or behind an image of a king enthroned and do their best to provide a naturalistic, if secondary, glimpse into space, Matisse deals with this motif direct. Matching paint and pattern for their own sake, he plays a freer, if cruder, game.

for example, have affected the way in which Europeans portray their own landscape. Where Dürer had visited Rome, and Rubens London, Delacroix thought nothing of going to Morocco or Gauguin of settling in the South Seas. It is significant that twentieth-century landscapists think nothing of exhibiting in America, a continent scarcely discovered when landscape painting started in Europe.

Realism achieved: back to base

Landscape painting, ever a pointer to the outside world, reflects this mood of change. After generations of painters had devoted themselves, in fits and starts, to creating an illusion of reality, they virtually ran out of problems. Space and light, for example, had not only been conquered but exploited in a myriad of ways. Research, such as Constable's, into cloud

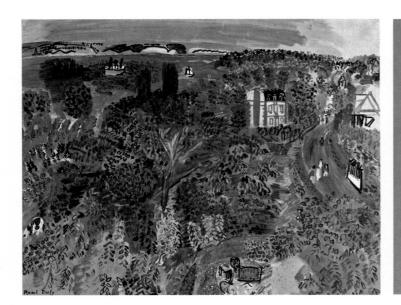

Dufy (1877-1953): Villerville, 61×100·3cm

A landscape with Dufy may well be a townscape or a seascape which is not so much painted as sketched with coloured lines over smooth grounds. The old idea of a sketch as a starting point has gone. Dufy, with his foolish arabesques and saucy blobs, creates a vivacious and spontaneous effect. Logic is played down (as in the wide panoramas of Kokoschka) colour used directly, and a fine sense of frivolity revealed.

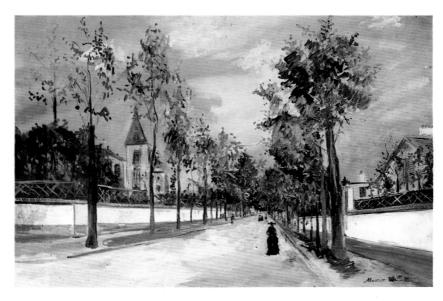

Utrillo: Residental Street, 53 × 76cm

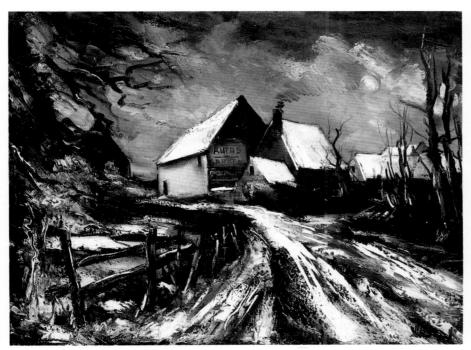

Vlaminck (1876–1958): Winter Landscape, 89×116cm

Vlaminck paints his snows and skies as a greedy man spreads butter. His paint is thick, and his knife marks are obvious. He is one of those painters whose work brings home the clear connection between an artist's style and the way in which he manipulates his actual materials. Monet, for example, could use paint freely - but his brush strokes are unique, like the loosely assembled notes in a piece by Debussy. Vlaminck's marks, on the other hand, are part of a thick paste, which his palette knife has ridged and blended. The vigorous way in which he applies his pigment makes for bold effects. Vlaminck's method, for example, is at odds with the satin finishes of the early Flemings or the delicate transparencies of the English watercolourists.

Klee: Idyll in a Garden City, 43 × 40cm

formations or the specific effect of light after rain, had been of a highly sophisticated standard. Subsequent painters (finding the demand for representation eased by photography) were left with two alternatives. One of these was to start from scratch and study pure form, as the Cubists did, taking Cézanne's studies as the starting point for publicizing a new range of abstract landscapes. The essence of landscape, which Leonardo had already recognized in patchy walls and glowing embers, and Turner had already moulded out of pure colour, became fashionable in its own right.

Paul Klee: an intuitive rebirth

Paul Klee's *Idyll in a Garden City* is an exquisite example of a modern 'landscape'. It is also innocently anarchic. With Klee, perspective points can vanish in all directions and

RIGHT **Dali**: The Persistance of Memory, 24×32.5 cm

Nash: The Pillar and Moon, $51 \times 76 cm$

Klimt: Chateau above the Lake, 90 × 70cm

seemingly simple outlines lead the eye a happy dance. Seen in the historical context of European painting, it is a cheeky, childlike image. But no amount of academic learning, even if displayed with sensitivity and conviction, has any real value, as decadent movements prove. (Thus the languid style of a late nineteenth-century artist such as Odilon Redon or Puvis de Chavanne is lifeless in comparison with Klee's delightfully fresh painting). Bored by the piled-up expertise of the past, he wanted to be 'as though new-born, knowing nothing, absolutely nothing, about Europe; ignoring poets and fashions, to be almost primitive'. The humility of trying to find a 'tiny, formal motive, one that my pencil will be able to hold without technique' led to the discovery of simple organic forms. These provide the basis of his aesthetic world (just as cells collect in patterns to build up plants and animals, or man-made structures conglomerate to produce towns and cities.) A painter such as Klee was intuitive in discovering the flexible, musical rhythms lying behind the apparent disorder of creation.

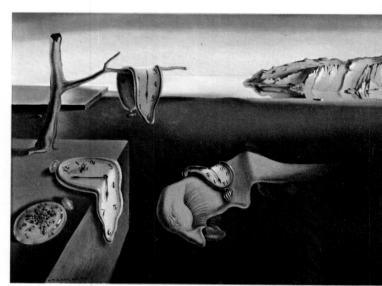

Chagall: The Repose of the Poet, 78×77 cm

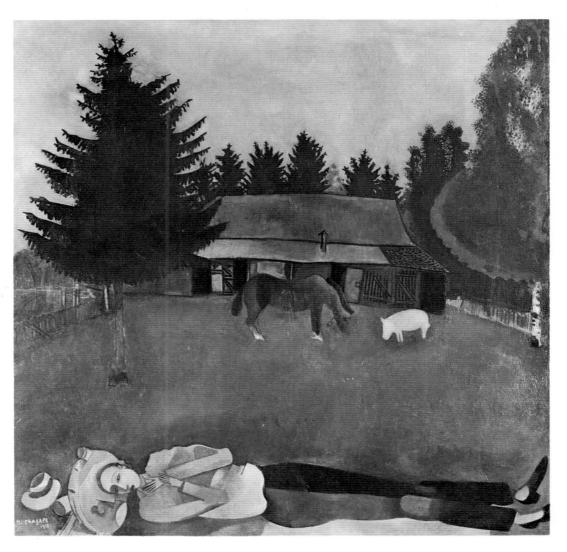

Another alternative: mental landscape

Once European landscapists had mastered the problems of creating realistic scenes, they were free to experiment in a wider sphere. Having completed a period of formal education, in which they learnt the language of illusion, they were then able to make the leap from solid earthly scenes to psychological ones, producing paintings which, reversing the didactic symbolism of the Middle Ages, are largely a matter of personal interpretation.

In a sense this has always been true, and landscapists such as Bosch can be seen as the forerunners of express-

Carra (1881–1966): *The Lighthouse*, 70×90cm

Just before Camille Pissarro became absorbed by Impressionism, he painted an English suburb. Uninteresting in itself, it is, nevertheless, upheld as a fine example of realistic painting. To accept this painting of Norwood as 'realistic' is tantamount to defining realism as the accurate rendition of the colours, shapes and surfaces we see about us. This is a material definition. Not everyone, however, has the same concept of reality. Some people, including eloquent philosophers such as Plato, define reality, first and foremost, in abstract terms. Plato, for example, believed that there were ideal prototypes for everything on earth, and that our earthly models were distinctly inferior to these 'real' ones. If one follows an argument like this, then Pissarro's image (which copies an 'actual' suburb, rather than drawing its inspiration from an 'ideal' one) is a poor, imitative thing - unlike Carlo Carra's 'metaphysical' landscape, which grew from an intellectual curiosity about the truth.

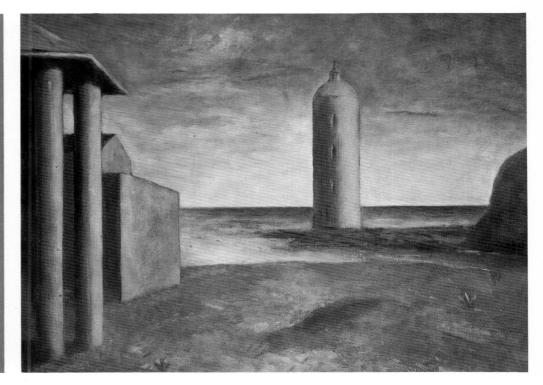

Landscape Painting: Shahn · Wyeth

ionists such as Van Gogh, or dream painters such as Chagall, who fulfil Leonardo's maxim that the painter is a 'creator of worlds'.

Belief creates reality

When Magritte, a thoroughly ironic modern master, makes his clouds escape their painted frame and move towards us

Shahn (b.1898): Pacific Landscape, 64×99cm

Delacroix, painting Dante and Virgil in a boat, filled his surrounding canvas with stormy waves, while Hokusai, depicting fishers and seaweed gatherers, delicately patterned their bodies with the linear rhythms of the swell. These nineteenth-century artists were deliberately using the sea as a source of visual drama and design. Looking at this twentieth-century painting, however, the sea plays a minor role. Although the picture is called a *Pacific Landscape*, it is not the sea, but the wide stony beach, and the small figure set at an angle to it, which dominate this composition. The hard, impersonally textured beach and the faceless figure combine to produce a feeling of isolation — of man as a bit of flotsam cast up by the ocean of life.

These statements are highly subjective (for one could, after all, infer that this figure was enjoying a peaceful afternoon nap) and indicate how the more abstract a work becomes, the more open it is to speculative interpretation. Pure abstracts (including those of Pollock and Rothko) should, therefore, be judged by individuals rather than be accepted, unthinkingly, like the Emperor's new clothes.

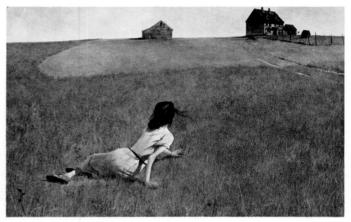

Wyeth: The World of Christina, 80×117.5 cm opposite Magritte: Vengeance, 47×35 cm

he is expressing a new freedom. Landscape painting, once a simple window on the world, has become a psychological interpretation of that world. The genre which was originally controlled by orthodox thought and symbolically restrained by the hedges of the *hortus conclusus*, now defies formal definition. This does not mean that it has lost force but rather the contrary. For it is accepted that civilizations are reflected in the environments they create, and in the same way people are now realizing increasingly that intellectual, emotional and spiritual states are reflected in different kinds of mental scenery. Landscape painting provides the perfect vehicle for personal interpretations of heaven and hell.

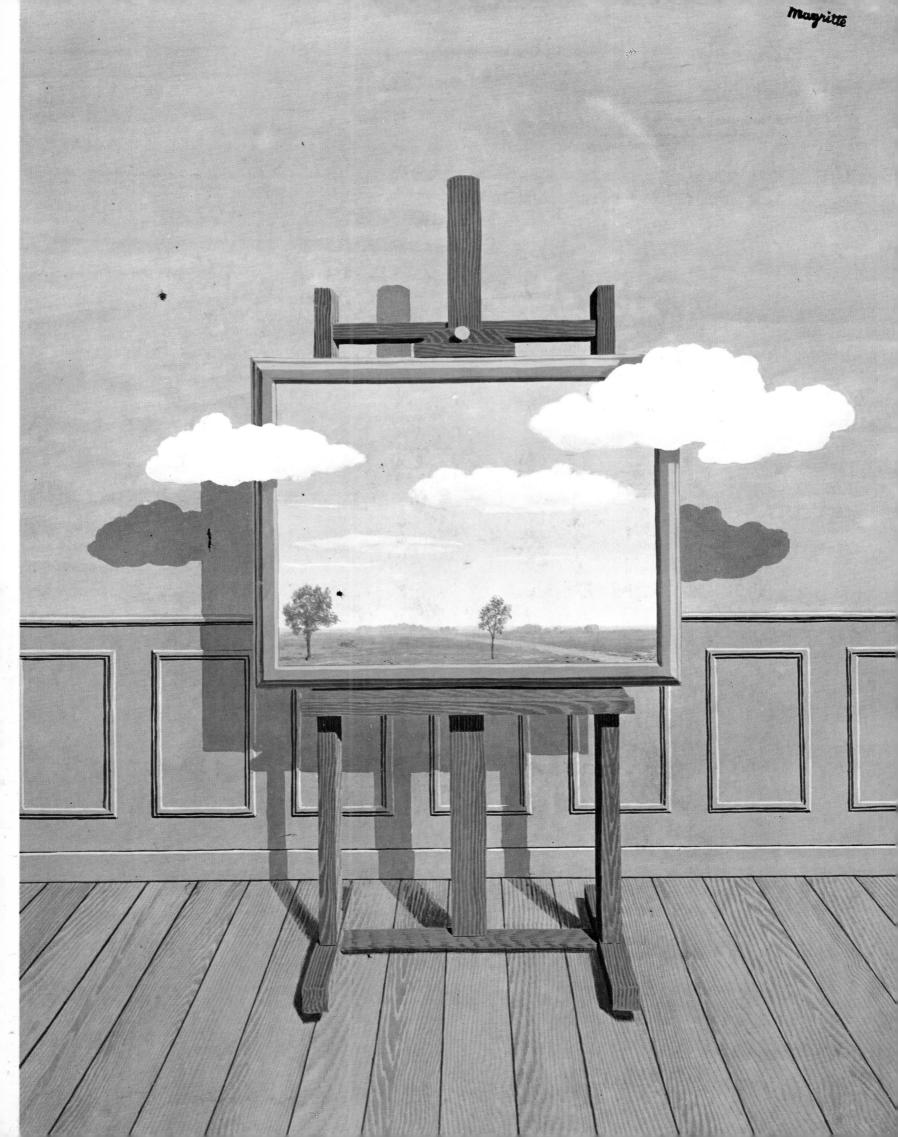

List of illustrations

Altdorfer: St. George, Munich, Alte Pinacothek, 31

Altdorfer: Suzanna and the Elders, Munich, Alte Pinacothek, 32

Angelico, Fra: *The Annunciation*, Madrid, Prado, 11 Bellini, Giovanni: *Allegory of Souls*, Florence, Uffizi, 16

Bellini, Giovanni: The Madonna of the Meadow, London, National Gallery,

Bellini, Gentile: Miracle of the True Cross at the Ponte San Lorenzo. Venice, Accademia. 17

Bosch: The Garden of Earthly Delights, Madrid. Prado. 36, 37 Bosch: St. John on Patmos, Berlin-Dahlem, Staatliche Museen. 36

Bruegel the Elder: The Fall of Icarus, Brussels, Musées Royaux des Beaux-Arts, 39

Bruegel the Elder: *Haymaking*, Prague, National Gallery, 39
Bruegel the Elder: *Hunters in the Snow*, Vienna, Kunsthistorisches Museum, 38

Bruegel the Younger: The Village, Prague, National Gallery, 34

Canaletto: Perspective, Venice, Accademia, 51 Carra: The Lighthouse, Prague, National Gallery, 77

Carracci, Annibale: Landscape with a Bridge, Berlin-Dahlem, Staatliche Museen 27

Cézanne: The House of the Hanged Man. Paris. Jeu de Paume. 67 Cézanne: The Landscape at L'Estaque. Sao Paulo. Museu de Arte. 67 Cézanne: The Rocky Landscape at Aix. London. National Gallery. 67

Chagall: The Repose of the Poet, London, Tate Gallery, 77

Claude Lorraine: The Archangel Raphael and Tobias. Madrid. Prado. 28

Claude Lorraine: Embarkation from Ostia, Madrid, Prado, 28

Claude Lorraine: Moses Saved from the Bulrushes, Madrid, Prado, 29

Claude Lorraine: Village Fete, Paris, Louvre, 29

Constable: The Admiral's House, Hampstead, London, Tate Gallery, 56

Constable: The Haywain, London, National Gallery, 57

Constable: Salisbury Cathedral from the Bishop's Garden, Sao Paulo, Museu de Arte, 57

Corot: The Winding Road, Basel, Öffentliche Kunstsammlung, 59 Courbet: The Lake at Neuchatel, Budapest, National Museum, 62

Cozens: The Lake of Albano and Castel Gandolfo, London, Tate Gallery, 58 Dali: The Persistence of Memory, New York, Museum of Modern Art, 76

Dufy: Villerville, Chicago, Institute of Art, 75

Dürer: Castle Courtyard, Innsbruck(?), Vienna, Albertina, 12

Eyck, Jan van: The Madonna of Chancellor Rolin, Paris, Louvre, 14, 15 Eyck, Jan van: St. Barbara, Anvers, Musée Royal des Beaux-Arts, 12 Gainsborough: Landscape at Drinkstone Park, Sao Paulo, Museu de Arte, 56 Cainchagangh: Mrs. Bichard Brinslay, Sharidan, Washington, National

Gainsborough: Mrs Richard Brinsley Sheridan, Washington, National Gallery. 54

Gauguin: Arearea, Paris, Jeu de Paume, 71

Gauguin: Breton Village under Snow, Paris, Jeu de Paume, 70 Gauguin: The Day of God, Chicago, Institute of Art, 72, 73

Giorgione: The Tempest, Venice, Accademia, 24, 25

Giovanni di Paolo: Paradise, New York, Metropolitan Museum, 9

Girtin: The White House, Chelsea, London, Tate Gallery, 58

Gogh, van: The Garden of Daubigny, Basel, Öffentliche Kunstsammlung, 68

Gogh, van: Meadow with Butterflies, London, National Gallery, 69

Gogh, van: The Rest, Paris, Jeu de Paume, 68

Gogh, van: Thatched Roofs at Montcel, Paris, Jeu de Paume, 68 Greco, El: View of Toledo. New York, Metropolitan Museum. 30

Guardi: View of the Grand Canal, Milan, Brera, 51

Hobbema: The Road to Middelharnis, London, National Gallery, 49

Hobbema: The Watermill, Amsterdam, Rijksmuseum, 49

Hokusai: Fuji, Tokyo, National Museum, 70

Klee: Idyll in a Garden City, Basel, Öffentliche Kunstsammlung, 76

Klimt: Chateau above the Lake, Prague, National Gallery, 76

Koninck: Landscape, Amsterdam, Rijksmuseum, 48

Lorenzetti: Scenes from the Life of the Blessed Humility, Florence, Uffizi, 6

Magritte: Vengeance, Anvers, Musée Royal des Beaux-Arts, 79

Mantegna: Adoration of the Shepherds, New York, Metropolitan Museum, 18, 19

Master of Flémalle: Virgin and Child and Saints in a Garden, Washington, National Gallery. 8

Matisse: The Blue Window, New York, Museum of Modern Art. 74 Matisse: The Riverbank, Basel. Öffentliche Kunstsammlung. 74

Metsys: The Triptych of St. Anne, Brussels, Musées Royaux des Beaux-Arts, 20, 21

Monet: The Bridge with Waterlilies, London, National Gallery, 63

Monet: Wild Poppies, Paris, Jeu de Paume, 63

Munch: Dance by the Edge of the Sea, Prague, National Gallery, 74

Nash: The Pillar and Moon, London, Tate Gallery, 76

Patinir: Charon's Boat, Madrid, Prado, 34, 35

Patinir: The Penitence of St. Jerome, New York, Metropolitan Museum, 33 Piero della Cosimo: Venus, Mars and Cupid, Berlin-Dahlem, Staatliche

Piero della Francesca: The Baptism, London, National Gallery, 22, 23 Pissarro: Orchard in Pontoise, Quai de Pothuis, Paris, Jeu de Paume, 62

Pissarro: Le Pont Neuf, Budapest, National Museum, 62

Pissarro: Entrance to the Village of Voisins, Paris, Jeu de Paume, 62

Pissarro: Woman in an Orchard, Paris, Jeu de Paume, 62

Pollaiuolo: Martyrdom of St. Sebastian, London, National Gallery, 20

Poussin: Landscape, Madrid, Prado, 29

Poussin: Landscape with Ruins, Madrid, Prado, 29

Poussin: Moses Saved from the Bulrushes, Paris, Louvre, 30 Rembrandt: The Mill, Wáshington, National Gallery, 45 Rembrandt: The Stone Bridge, Amsterdam, Rijksmuseum, 5 Renoir: La Grenouillère, Stockholm, Nationalmuseum, 61

Renoir: The Path through the Tall Grasses. Paris. Jeu de Paume, 60, 61 Rousseau, 'Le Douanier': Virgin Forest at Sunset, Basel. Öffentliche Kunstsammlung, 71

Rubens: The Judgement of Paris. London, National Gallery, 43 Rubens: Landscape with a Rainbow, Munich, Alte Pinacothek, 42

Rubens: The Wild Boar Hunt, Dresden, Gemäldegalerie, 42

Ruisdael, Jacob van: Cornfields, New York, Metropolitan Museum, 46, 47 Ruisdael, Jacob van: The Jewish Cemetery, Dresden, Gemäldegalerie, 48 Ruysdael, Salomon van: The Ferryboat, Amsterdam, Rijksmuseum, 44 Seurat: The Banks of the Seine, Brussels, Musées Royaux des Beaux-Arts, 66

Seurat: Bathing at Asnière, London, National Gallery, 66 Seurat: La Grande Jatte, Chicago, Institute of Art, 64, 65 Shahn: Pacific Landscape, New York, Museum of Modern Art, 78 Siberechts: Landscape with a Rainbow, London, Tate Gallery, 58

Sisley: The Flood at Port-Marly, Paris. Jeu de Paume. 59 Sisley: The Island of the Grande Jatte. Paris. Jeu de Paume. 59

Titian: The Pardo Venus, Paris, Louvre, 26

Titian: St. John the Baptist, Venice, Accademia, 26

Turner: Caernarvon Castle, Sao Paulo, Museu de Arte, 55

Turner: Snowstorm, Avalanche, and Inundation, Chicago, Institute of Art, 55

Turner: Windsor Castle Seen from Salt Hill, London, Tate Gallery, 56 Turner: Yacht Approaching the Castle, London, Tate Gallery, Titlepage

Uccello: *The Hunt*, Oxford, Ashmolean Museum, 10 Unknown Florence artist: *The Thebaid*, Florence, Uffizi, 7 Utrillo: *Residential Street*, Prague, National Gallery, 75

Velazquez: View of the Garden of the Villa, Rome, Madrid, Prado, 52 Vermeer: The Little Street in Delft, Amsterdam, Rijksmuseum, 50 Vlaminck: Winter Landscape, Sao Paulo, Museu de Arte, 75 Watteau: Embarkation for Cythera, Paris, Louvre, 53

Wilson: Llyn-Y-Cau, Cader Idris, London, Tate Gallery, 58 Wootton: The Beaufort Hunt, London, Tate Gallery, 58

Wyeth: The World of Christina, New York, Museum of Modern Art, 78

Bibliography

CIRLOT. J. E.: A Dictionary of Symbols, 1962 CLARK, KENNETH: Landscape into Art, 1949 GOMBRICH. E. H.: Norm and Form, 1966

HOLT, ELIZABETH G.: A Documentary History of Art, Vols. I, II, and III

SANTINI, PIERRE-CARLO: Modern Landscape Painting, 1972